BLACK AMERICA SERIES
HAMPTON
VIRGINIA

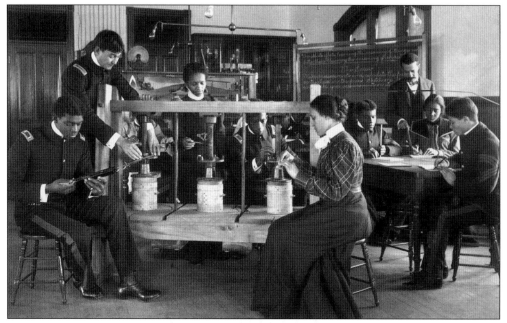

(Front cover) This picture, taken between 1899 and 1900, depicts Hampton Normal and Agricultural Institute students in an agricultural science course. The picture was taken to show the ingenuity and studiousness of black students for the 1900 World Expo in Paris. Note the male school uniforms and the high necklines on the female dresses. (Courtesy of Frances Benjamin Johnston/Library of Congress Prints and Photographic Division.)

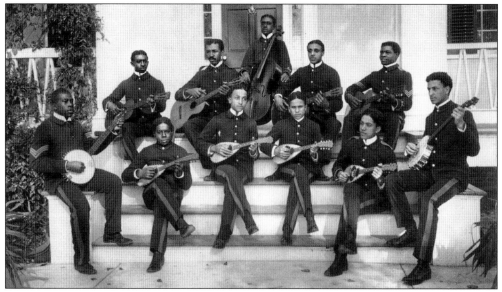

(Back cover) This picture, also taken between 1899 and 1900, depicts Hampton male students playing various stringed instruments: guitars, banjos, mandolins, and cello. Note the uniforms and crossed legs. Also note that some males' hair is parted in the middle, a style very common among black men in this day. This picture was taken to show the creativity of black people for the 1900 World Expo in Paris. (Courtesy of Frances Benjamin Johnston/Library of Congress Prints and Photographic Division.)

Black America Series

HAMPTON
Virginia

Colita Nichols Fairfax

ARCADIA

Copyright © 2005 by Colita Nichols Fairfax
ISBN 0-7385-1810-7

Published by Arcadia Publishing
Charleston SC, Chicago IL, Portsmouth NH, San Francisco CA

Printed in Great Britain

Library of Congress Catalog Card Number: 2005922729

For all general information contact Arcadia Publishing at:
Telephone 843-853-2070
Fax 843-853-0044
E-mail sales@arcadiapublishing.com
For customer service and orders:
Toll-Free 1-888-313-2665

Visit us on the internet at http://www.arcadiapublishing.com

This body of work is dedicated to my parents,
Mrs. Brenda Dabney Nichols and the late Dr. Paul Nichols,
who taught me to love history and embrace knowledge.

Contents

Acknowledgments	6
Introduction	7
1. Freedom Fortress	11
2. Hampton University	25
3. Occupations and the Entrepreneurial Spirit	49
4. Building Communities	67
5. Serving God, Saving Souls	83
6. The Three Rs	97
7. Striving for Political Power	111
8. Bay Shore	115
9. Langley Field and NASA	121
Notes	127

ACKNOWLEDGMENTS

History is precious to all people, and I am grateful to those who assisted in this beginning endeavor to preserve African American history in Hampton, Virginia. In addition to the merciful blessings of the Creator, special thanks are offered to Michael Cobb, archivist of the Charles Taylor Memorial Library/City of Hampton, Cheyne and Chester Bradley Collections; Mr. Reuben V. Burrell, Hampton University photographer; assistant archivist Annette Montgomery, Norfolk State University Archives; City of Portsmouth Public Library, Mrs. Edie Carmichael; representatives of the Afro-American Historical and Genealogical Society—Hampton Roads Chapter Mrs. Selma Stewart, Mrs. Josephine Harmon Williams, Mr. Lewis C. Watts, Ms. Stephanie Thomas, and Mrs. Catherine Howard; Davis J. Johnson of the Casemate Museum; Mrs. June Jones, manager, and Mrs. Mary Johnson, director, of the Little England Chapel; and Mrs. Lillian Williams Lovett, archivist of the J. Thomas Newsome Museum and Carrie Brown Cultural Center; The Daily Press, Inc.; the Library of Congress—Frances Benjamin Johnston Collection; and the Hampton University Museum Archives.

I also thank those persons who provided photographs and qualitative interviews: Mrs. Helen Thornton Fairfax, Jeffrey Roberts, Paige and Carolyn Washington, Roosevelt Wilson, Howard C. Cary Sr., Gerri Hollins, Mrs. Thelma G. Boone, John DeShetler, Mrs. Bessie G. West, Ms. Mary Helen T. Jackson, Mr. Wilbur "Chuck" Christian, Dr. Mary T. Christian, Ms. Aurelia Parker, William Parker, Albert and Louise Walker Simpson, Mrs. Lillie Mae Johnson Jones, Mstr. Sgt. Jarvis Taylor, Mstr. Sgt. Grant Williams Sr., Lt. Col. Francis Horne, Mrs. Sadie Mannes Brown, Mrs. Catherine T. Barbour, Dr. Turner M. Spencer, Mrs. Frances Pickett Manns, Mrs. Lillian Epps Johnson, Mrs. Bertha W. Edwards, Mrs. Mae Breckenridge-Haywood, Rev. Andre Jefferson, Mrs. Phyllis D. Crudup, Ms. Brenda Wharton-Taylor, Mrs. Margaret Jones Wilson, Mrs. Gail Boyd Jones, Ms. Sylvia Boyd Gaffney, Mrs. Pearl M. Smith, Ms. Cora Mae Reid, Harold and Mildred Barber Jordan, Mr. Lewis Lovett, Wilbert Lovett, Heyward Lovett, Clarence "Jap" and Sadie Mann Curry, Frank C. Mann, Thomas Nottingham, Mrs. Julia R. Bassette, Mr. George Wallace Jr., Mr. Ermany Taylor, Mrs. Ellen Lively Bolling, George and Linda Jackson, Mrs. F. Juanita Haltiwanger, Dr. Katherine Johnson, Mrs. Daisy W. Alston, Robert and Celestine Wynder Carter, Mrs. Delores Gayle, Rev. William and Mrs. Louise Martin Webster, Dr. Melvin Simpson, Mrs. Bonita E. Williams, Mr. Michael Chapman, Mrs. Ann N. Rosemond, Mr. Charles Brown, Sgt. William Veals, and Mrs Hattie Lucas.

My heart becomes full as I thankfully acknowledge the most important source of support—my husband, Anthony E. Fairfax. His constant expression, "Babe, you can do this," coupled with his own energy to locate pictures, internet sources, and ideas were so vital to this contribution. Whenever I fatigued, I looked at our daughter, Layla, whose very existence reminds me that after our lifetime, history and the human condition continues.

INTRODUCTION

History is an informative science that is often illusory if not applied in proper contexts. In American society, policies and laws influence the creation and re-creation of human behavior and culture among people who struggle to exist under such policies. Thus as history is created, it is under the influence and stress of certain social policies. This intersection of history and social policy creates a novel vantage point to intellectually appreciate such an analysis of the past. This assemblage includes a discussion on those policies having the most palpable affect on the vicissitudes of black people. Such a historiography is so extensive and multifarious it is really impossible to share every aspect of the contributory nature of black people in the development of Hampton. There are so many aspects that were not included because of the unavailability of pictures. However, this effort is not the final word, but should be viewed as a beginning documentation leading to future work that will immortalize the participation of black people in a historic place such as Hampton.

In the 1500s, the land now known as Hampton was called Kecoughtan, named after the native people who resided there. This land was the scene of highly organized societies found in the native peoples of the Anishinabe or Algonquin Indian Nation. Led by Chief Pochin, they consisted of the Kecoughtans, Pamunkey, and Nansemond ethnic groups, who also affiliated with the Powhatan Confederacy, the Chickahominy, and Mattaponi people for centuries. These persons were agriculturalists, herbalists, shamans, hunters, fishermen, traders, and weavers. As Spanish and English invaders began to conquer these groups, physical signs of their existence disappeared because of broken treaties and wars. There were African explorers, such as Estavanico from Morocco, who traveled with Spanish expeditions and displayed the versatile talents of native African people, before they became known as "slaves."

In 1619, African indentured servants were discharged at Point Comfort, west of Fort Monroe, marking the beginning of the existence of African people in the Americas. From 1619 to about 1660, Africans could earn their freedom and experience some of the same liberties as whites. Although a small percentage of Africans were free and landowners, Act V, Laws of Virginia, October 1670, placed limitations on the privileges enjoyed by white male landowners. Act V stated, "No Negro or Indian though baptized and enjoying their own freedom shall be capable of any purchase of (white) Christians, but yet not be debarred from buying any of their own kind." In 1634, a portion of Kecoughtan was renamed Elizabeth City County. With the Chesapeake Bay on the east and Back River on the north, this land is almost entirely surrounded by water. It was the first English-speaking colony prior to the popular Jamestown settlement. Hampton became the county seat for Elizabeth City County, and it became a town as early as 1705 and finally incorporated in 1849.

As Virginia began to legally sponsor the tragedy of enslavement in 1661, the great increase in free African labor started with the advent of plantation agriculture. The Virginia colony

enacted legislation to ensure the supply of free labor by ensnaring Africans in perpetual servitude for their entire lives. Between 1660 and 1680, Virginia enacted slave laws restricting the freedom of blacks and legalize differential treatment for blacks and whites. So in addition to the free labor, legal sanction allowed for the domestic terrorism of African people. Further slave laws and black codes in Virginia passed between 1680 and 1705, reflecting racism and the deliberate separation of blacks and whites. Skin color became the determining factor to police the conduct and mobility of enslaved Africans and to ensure a penalty in whippings, resistance, and dismemberment. Despite these policies, Cesar Tarrant, a former enslaved person in Elizabeth City County who was a licensed navigator and considered a war hero of the seas, engaged his talents in the American Revolution of 1775. He was freed by a special act of the Virginia Assembly in November 1789, although his wife and children were still enslaved. To honor his contribution and memory, the City of Hampton named the Cesar Tarrant Elementary School after him in 1970.

In the 19th century, soil exhaustion ushered in other industries that earned Elizabeth City County's reputation as a seafood giant.[1] Fishing, crabbing, oystering, and tourism were all burgeoning industries. Fort Monroe, built during the American Revolution, became home to many troops stationed there and provided a steady course of income. Participating in these industries were free black people in addition to enslaved blacks, who were able to hire themselves out to earn extra money that would be used to purchase their freedom, the freedom of their family members, and land. Many free black families shared bloodlines with white families who helped them to become educated, become artisans, and earn property rights. Cary Nettles, David Carry, Samuel Dewbre, Richmond Hambleton, William Taylor, Jim Lester, James Bailey, Mary and Thomas Peake, Samuel Herbert, A. W. E. Bassette, Warren Smith, and others are documented names of free black persons in Elizabeth City County.

During the Civil War, the Contraband Policy was enacted to dispute the earlier Fugitive Slave Law. Since Virginia seceded from the Union, the latter policy was no longer applicable. Col. Benjamin Butler created the Contraband Policy not to return escaped blacks to their "masters." These persons were held as "contraband of war"; by targeting the Southern industry of enslavement, it was just the law needed to attract thousands of freedmen to Fort Monroe. Black people settled in Slabtown, Downey Farm, and the Grand Contraband Camp recreating city life, since whites had abandoned the town, resulting in post-enslavement community life. Churches were formed within those communities, adding to the unique experience of the insulated black community during the coming days of legalized segregation. Newly freedmen became leaders instantaneously due to their own ingenuity. Rev. Zechariah Evans, Rev. William Roscoe Davis, Rev. John Smith, and Rev. Ebenezer Byrd aided many women and men on the path to starting churches. Names such as Zion Baptist, First Baptist, Bethel A.M.E., Queen Street Baptist, Antioch Baptist, and Wine Street Baptist are among those first black churches post-enslavement. The churches sustained the community spiritually and emotionally after the Emancipation Proclamation of 1863, which was an edict freeing enslaved people in particular territories in America.

The American Missionary Association (AMA) decided that a training school should be made available to the freed population. Since freed blacks were already learning to read and write from devoted schoolteachers such as Mary Peake, mission schools, most notably the Butler School (renamed the Whittier School), were formally established. The AMA helped to create the Hampton Normal and Agricultural Institute in 1868 (known as Hampton University as of 1984), with Gen. Samuel Chapman Armstrong serving as its first "principal." In the 20th century, the institute would house the George P. Phenix High School.

Communities or pockets of integrated areas included Old Hampton, Lincoln Park, Aberdeen Gardens, Old Northhampton, Newtown, Lincoln Park, an area of Buckroe, Garden City, and Dunbar Gardens. Neighborhood schools such as Aberdeen School, Semple Farm School, and Back River School educated their own children. The city of

Hampton would not have a high school for black children until 1968, mandated as a result of the desegregation policy.

During the Reconstruction Period between 1865 and 1877, citizens in the process of rebuilding the country from the physical remnants of the Civil War witnessed Elizabeth City County's first black political leaders, who molded and shaped the policies of city hall and Virginia. After Reconstruction, there was not another black person to serve on city council until 1974. In the interim, there were political action groups that represented the community's issues.

As the 20th century unfolded with newly formed schools and churches, ingenuity, intellectualism, and creativity resulted in black business ownership, despite the hardships associated with legal segregation. In addition to participation in the local industries of crabbing, oystering, fishing, farming, landscaping, and contracting, professional blacks, who were attorneys, physicians, pharmacists, bankers, and teachers, added to the growing number of resourceful persons for the community to benefit from. A group of businessmen started Bay Shore Beach, an all-black resort that attracted thousands of vacationers from Richmond, Washington, D.C., Baltimore, Elizabeth City, and other areas.

There were hundreds of businesses that provided financial stability to churches, neighborhoods, activities, organizations, and home ownership prior to the first series urban renewal policies of the 1950s. The Housing and Urban Development Act and the New Communities Act of 1968 and, subsequently, the Housing and Community Development Act of 1974 obliterated those black business districts, neighborhoods, and schools that had stabilized the community throughout most of the 20th century. Apartment complexes, government project housing developments, and Interstate 64 devastated those communities that had existed since the 1860s. These business districts would not be re-erected due to low repayment.

Elizabeth City County, the town of Phoebus, and the county seat of Hampton were incorporated as the City of Hampton in 1952. Hampton became nationally significant due to the proximity of Langley Air Force Base/NASA and the integrating of its school system, coupled with the prominence of Hampton University; however, the city would not have its opulent past and present inimitability if not for African Americans.

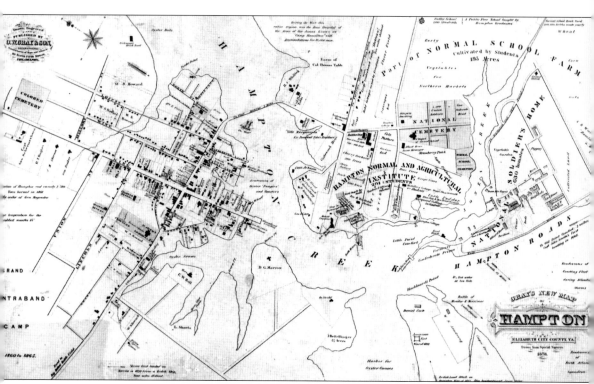

This map is of Elizabeth City County in 1878. The Grand Contraband Camp is noted to have existed from 1860 to 1865 on the lower left-hand side. Hampton Normal and Agricultural Institute is in the middle of the map. The top half of the map has small arrows pointing to Freedom Fortress and the Large Contraband Camp "Slabtown." The Butler School is located in the top right portion of the map. (Courtesy of Reuben V. Burrell.)

One

FREEDOM FORTRESS

Fort Monroe, or as it was titled, Freedom Fortress, signaled a special significance for black people seeking freedom. Named after Pres. James Monroe, it was built to fortify Elizabeth City County between 1819 and 1834. It is America's only fort continuously occupied by the army, and the only stone fort encircled by a moat. Work on the fort was done by military prisoners, augmented by civilian artisans from the North and some hired enslaved persons.[2] During the Civil War, Fort Monroe remained in possession of Union forces. Brig. Gen. Benjamin F. Butler was in command of the fort when, on May 23, 1861, three men, Shepard Mallory, Frank Baker, and James Townsend, escaped from the plantation of Col. Charles Mallory of Hampton seeking freedom.[3] Butler decided not to honor the request to return the fugitives under the Fugitive Slave Law passed as part of the Compromise of 1850, which made it tougher on enslaved Africans who ran away and demanded stricter punishment for those aiding them. Since Virginia had seceded and was no longer a part of the Union, he did not uphold that law. Additionally, as a military strategist and attorney, Butler realized that such an action would have an injurious affect on the Southern states' industries using free African labor.

The Contraband Policy involved confiscating enslaved Africans as "contraband of war" and overrode the Fugitive Slave Law and Black Codes of Virginia. The contrabands, as they were called, were fed and sheltered and worked within Freedom Fortress. As this policy became standard among those Union forts, more troops were needed to support the fort. As this news traveled among those enslaved people, thousands risked capture and fled to Freedom Fortress. Black people either worked for the Union army or developed opportunities of their own. For example, Charlotte White, known as "pie woman," made a living baking and selling pies, in addition to working for the family of Col. John Tidball.

Those persons escaping enslavement were of great assistance to the Union military and naval forces, serving as cooks, servants, stevedores, carpenters, laborers, scouts, nurses, laundresses, teamsters, foragers, blacksmiths, and dispatches, and they received rations and small monthly wages.[4] They also served as "black dispatches," a common term used among Union military men for intelligence on Confederate forces.[5] Notably, the "black Moses," Harriet Tubman, was at Freedom Fortress in 1865. Thomas Peake, the husband of teacher Mary Smith Peake, looked like a white person and was a black dispatcher for the Union.[6] George Scott observed that Confederate forces had thrown up two fortifications between Yorktown and the fortress. Scott provided Butler with this intelligence.[7] The First and Second United States Colored Calvary and Battery B, Second United States Colored Light Artillery, were organized at Fort Monroe and Camp Hamilton, and the first United States Colored Calvary, organized where the business section of Phoebus is today, served gallantly.[8]

Confederate general John B. Magruder learned that Butler intended to use Hampton to house contrabands. Magruder ordered that the city be burned, determining that Hampton would not be used as a "harbor of runaway slaves and traitors." He realized that the Confederates could not hold the town due to its proximity to Fort Monroe.[9] The irony of this outcome is what Magruder tried to prevent: the establishment of the Grand Contraband Camp atop Hampton's ruins.[10] Two other camps were created called Slabtown and Downey Farms, resulting in all-black enclaves that would soon become beloved communities. The name "Slabtown" was used because after the burning of Hampton, blacks used available construction material

and built their shanties adjacent to standing chimneys. Those shanties were built so well that the U.S. military often evicted the contraband so those homes would be used by the troops, creating resentment and animosity between the new freedmen and Union troops.[11]

Blacks resurrected the town by giving streets around the Grand Contraband Camp (what is now presently downtown) names such as Union, Lincoln, Grant, Washington, and Liberty (presently Armistead). From the ruins of the Civil War, landowning whites throughout the rural areas abandoned their property to escape intersection with Union troops. Black families built shanties around the chimneys and farmed the land, only to have that land returned to its previous owner. Blacks occupying such land were kicked off immediately without warning and charged with trespassing. There was no legal redress for this common occurrence.

So whereas the Contraband Policy protected freedmen during the war, postwar time did not honor the Contraband Policy. In addition, there were no other policies or laws in place to protect the rights of the freedmen. Returning white citizens, Union troops, and indifferent Northern missionaries were three different groups of persons that the freedmen interacted with as they worked to create a space of freedom for themselves. Black soldiers who were enlisted in 1863 "fought energetically and bravely—none more so,"[12] yet suffered mistreatment. In *The Christian Recorder*, one soldier wrote, "Our families . . . are this day suffering for the natural means of subsistence, whose husbands and fathers have responded to the country's call. . . . We ask no elevation further than our rights as men and natives of this country. Our wives and children are as near and as dear to black men, as the white men are to theirs."[13] General Butler worked to ensure that the Southern branch of the National Soldiers' Homes would be accessible to black soldiers. The first member of the Soldiers' Home to be buried in the Hampton National Cemetery was Levi Jones, a veteran of Company E, 5th U.S. Colored Infantry, on May 14, 1871.

Treatment by the troops resulted in the denial of rations to the contraband community. The withholding of food, clothing, and the means to purchase firewood in the midst of winter and/or pirating rations often occurred. Also, the withholding of wages by diverting wages to other funds; pillaging freedmen's homes; looting and raping women; stealing lifestyle, lumber, and other vitalities; and failing to prosecute white criminal behavior were everyday tribulations. Black homes were removed without permission if they inhibited the movement of Union troops.[14] This malevolent treatment resulted in massive hostility, and without any system of redress, the freedmen had no choice but to defend the community. The American Missionary Association (AMA) arrived in Hampton in 1862 to establish mission schools and proselytize freedmen to Christianity. The AMA was unwilling to confront the Union troops or Southern citizenry about their treatment, but quickly perceiving the social inequities of the freedmen did not allow for the kind of relationship that would be appreciated in the contraband community. The Emancipation Proclamation of 1863, read under Emancipation Oak that stands today on Hampton University's campus, was the policy that gave the freedmen the right to say they were free, despite systematic neglect. This great oak has been selected by the National Geographic Society as one of the 10 great trees in the world.

At the end of the Civil War in 1863, there were 40,000 freedmen, 25,000 of whom were in refugee settlements near Hampton.[15] Schools were started at Fort Monroe, Camp Hamilton, at the Chesapeake Female College, and in the home of ex-President Tyler on East Queen Street. Butler used government funds to build a school for the children of the contraband. It endured for a quarter of a century under the name Butler School, which stood south on County Street, west of Zion Baptist Church. General Butler also turned over to families the confiscated farms where, even today, their descendants reside on Butler Farm Road in Hampton.[16] Congress created the Bureau of Refugees, Freedmen and Abandoned Lands in the War Department, with the goal of protection, land distribution, educational training, and development. It is through this act that the Freedmen Bureau was established. In 1868, Brevet Brig. Gen. Samuel C. Armstrong, an AMA missionary, started Hampton Normal and Agricultural Institute to educate those "contrabands" who remained in Hampton searching for freedom.

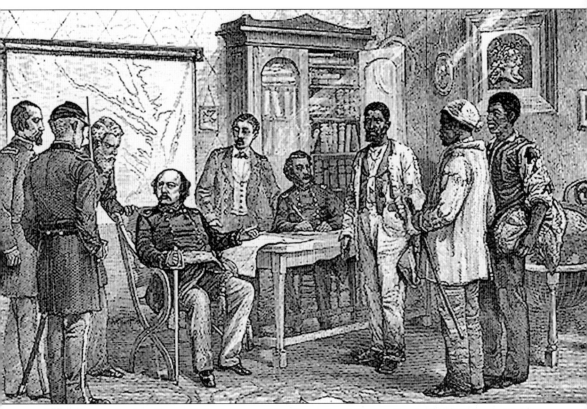

This picture depicts General Butler, possibly discussing his new Contraband Policy with his advisors and three gentlemen who escaped enslavement, Shepard Mallory, Frank Baker, and James Townsend. (Courtesy of the Casemate Museum.)

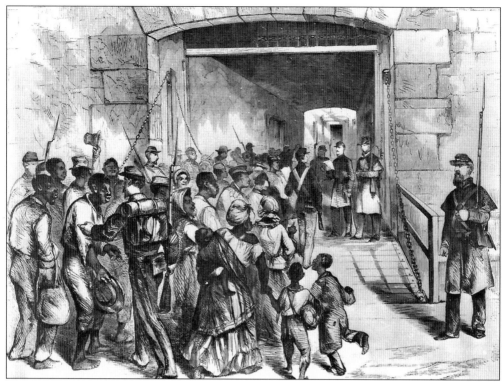

This *Ladies Illustrated Weekly* illustration shows enslaved Africans arriving at Freedom Fortress at the east gate. Notice the woman with little children and the man without shoes. (Courtesy of the Casemate Museum.)

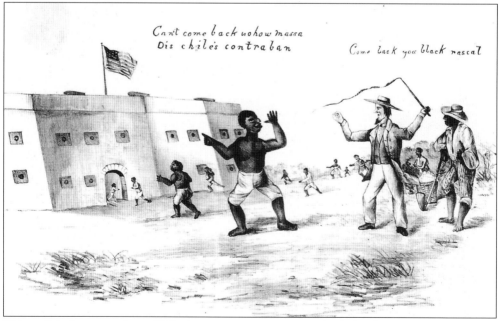

This political cartoon from 1863 shows persons escaping the lash of white slaveholders by seeking refuge at the Freedom Fortress. (Courtesy of the Casemate Museum.)

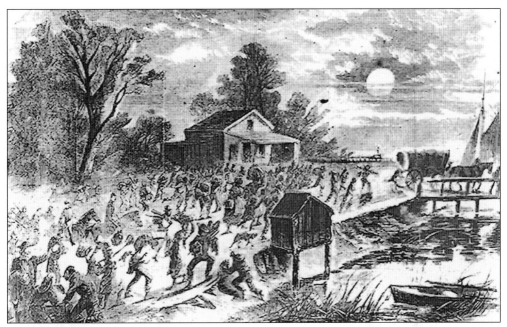
This *Harper's Weekly* illustration depicts the stampede of blacks toward Freedom Fortress in 1861. (Courtesy of the Casemate Museum.)

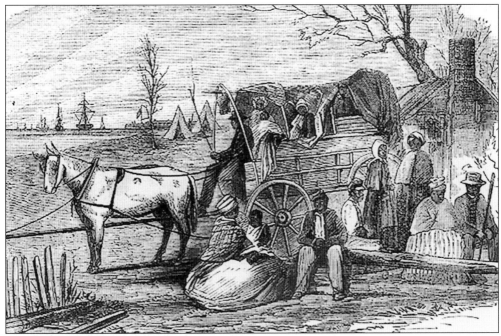
In this picture from *Harper's Weekly*, a family is shown traveling by buckboard to Freedom Fortress in 1861. This picture depicts the sojourn of many families to the fort. (Courtesy of the Casemate Museum.)

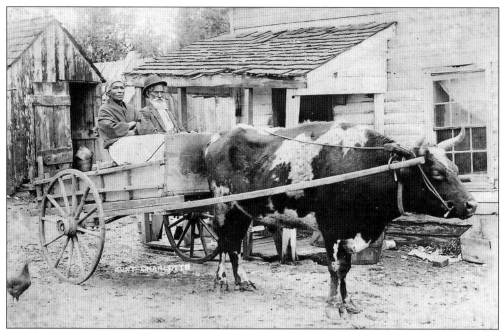

Charlotte White, also known as the "pie woman," sold pies for a living by oxcart. She is an example of how newly freed persons used their skills to make a living post-enslavement. The gentleman beside her may have been her husband. (Courtesy of the Casemate Museum.)

Charlotte White also worked for Col. John Tidball. One should notice she is standing beside the same oxcart used to showcase her pies. Many persons like her worked for themselves as well as for white families. (Courtesy of the Casemate Museum.)

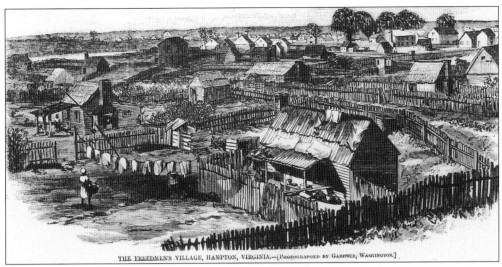

This is the freedmen's neighborhood called Slabtown shown in *Harper's Weekly*. Notice the clothesline, fences, and the scraps of various materials covering the roofs. (Courtesy of the Casemate Museum.)

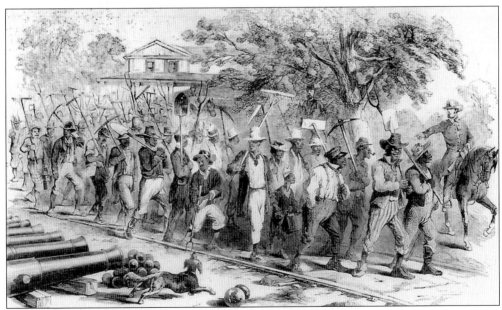

This illustration shows the contrabands going to work in 1861. *Leslie's Illustrated* called it "Morning Mustering." (Courtesy of the Casemate Museum.)

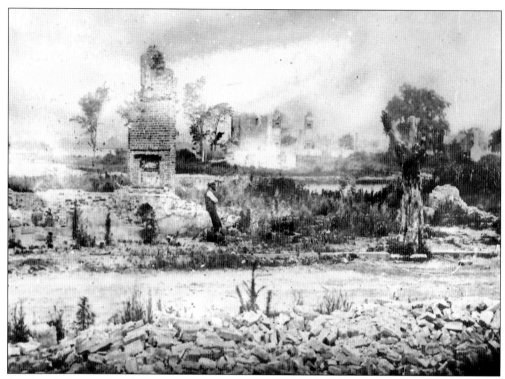

This picture depicts the county seat of Hampton after the Confederate troops burned it in August 1861. Many chimneys survived, and the contrabands built shanties around them. (Courtesy of the Casemate Museum.)

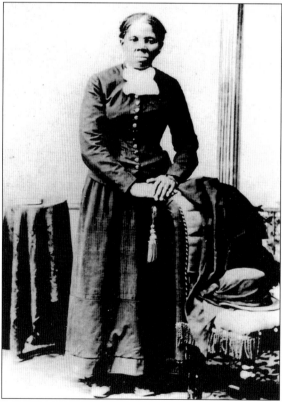

This is Harriet Tubman, "black Moses." Although known for her life-risking journeys to free enslaved Africans, she also contributed to the Union strategy through her role as a dispatcher. She went to Freedom Fortress in 1865. (Courtesy of the Casemate Museum.)

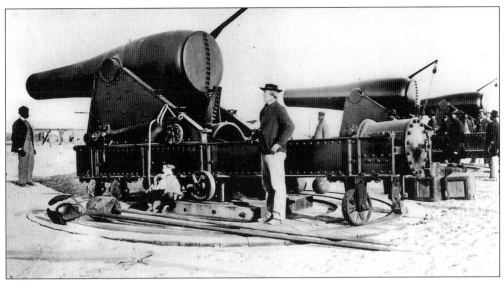
The freedmen held many skilled posts at Freedom Fortress. Here is a black man working with a 15-inch Rodman gun. (Courtesy of the Casemate Museum.)

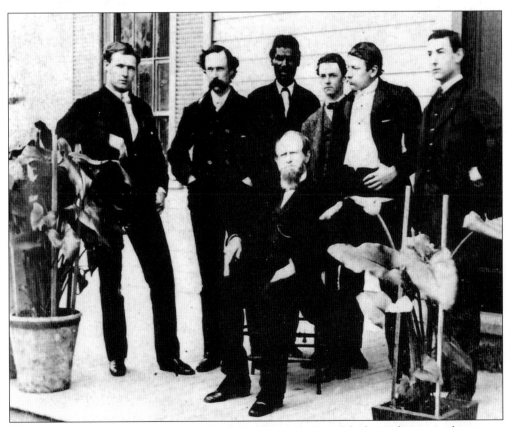
These men are the engineers at Fort Monroe. Notice the lone black gentleman in the group. (Courtesy of the Casemate Museum.)

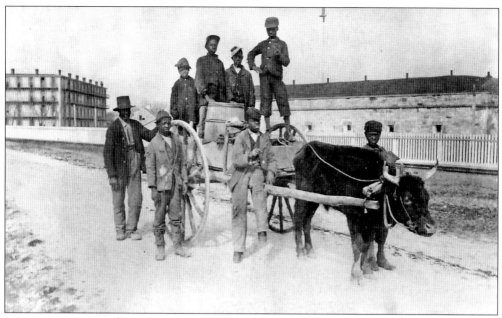
This picture shows black men working around Freedom Fortress about 1890. Oxcarts pulling a buckboard were the primary mode of transportation. (Courtesy of the Casemate Museum.)

The Freedman's Bureau established its state headquarters at Freedom Fort, making it easily accessible by Union troops, the AMA, and the freedmen. (Courtesy of the Casemate Museum.)

This was a church near Freedom Fortress that had just held Sunday school in 1892. The parishioners are wearing hats. Notice the bell in the steeple. (Courtesy of the Casemate Museum.)

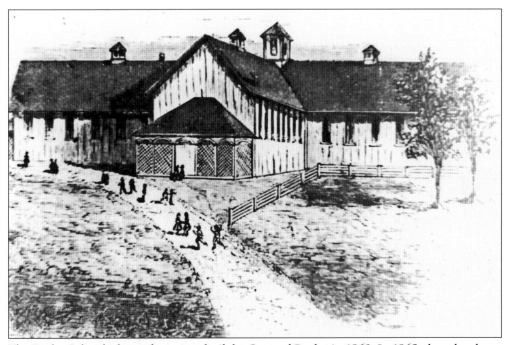

The Butler School, shown here, was built by General Butler in 1863. In 1865, the school was turned over by the government to the AMA, which supplied teachers until it was turned over to Hampton Normal and Agricultural Institute. (Courtesy of the Casemate Museum.)

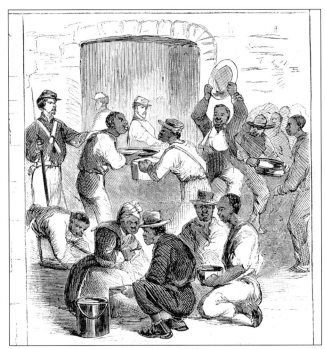

Men and women are shown here dividing rations for food, clothing, lumber, and other items used to survive. (Courtesy of Norfolk State University Archives.)

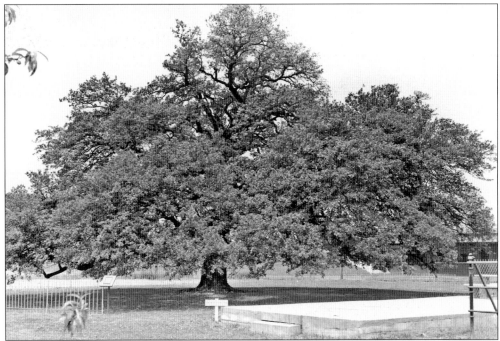

It is under this great tree that the Emancipation Proclamation was read in 1863, hence the name Emancipation Oak. Mary Peake taught many children of freedmen under this tree. It is on the Virginia Historic Registry, and there is a landmark posted near this hallowed ground. This picture was taken around 1939, and the tree is now a part of the campus of Hampton University. Many local black politicians have announced their candidacy under this tree. (Courtesy of Reuben V. Burrell.)

This is Mrs. Mary Smith Peake, pioneer teacher who taught enslaved Africans to read and write prior to the Civil War. She was married to Thomas Peake, who was a dispatcher for the Union army and later served as a leader in the community. Mary Peake died of tuberculosis at the age of 39. The city of Hampton named an elementary school in her honor. (Courtesy of Hampton University Museum Archives.)

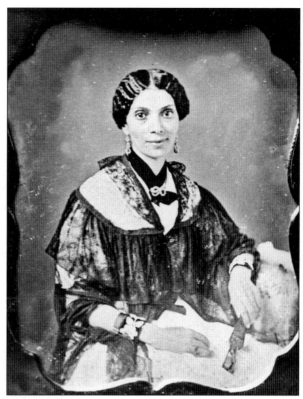

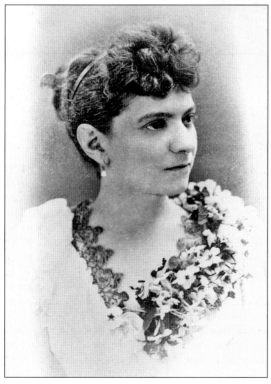

This is Daisy Peake, the only child of Mary and Thomas Peake. (Courtesy of Hampton University Museum Archives.)

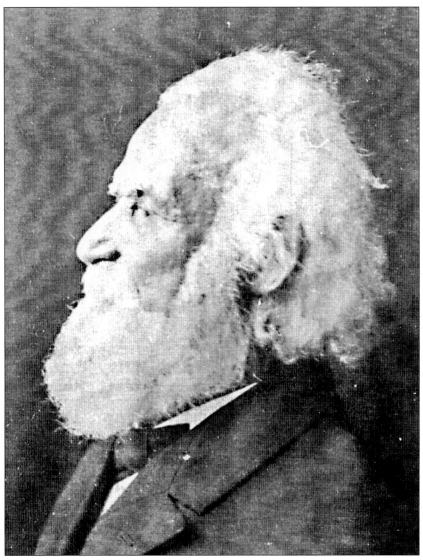

This is the legendary William Roscoe Davis. His mother was a Madagascar woman who was raped by his father, a white shipmate, during her voyage to Virginia in the 1830s. He was raised in Norfolk, where he learned to read and write from his master. He escaped to the Freedom Fortress, becoming an original contraband. His eloquence, dignity, vivid articulation, and religious views resulted in Davis becoming a minister and a progressive leader. Davis went on a speaking tour in the North to raise money for the AMA. He scoffed at the educational philosophy of Hampton Normal and Agricultural Institute, disagreeing with the vocational philosophy of the school toward its students, because as former enslaved people, they had worked all of their lives. He married Nancy Davis, sister of Thomas Peake, and had seven sons and one daughter. Davis purchased his wife's freedom, although the plantation family refused to release her; he contested the issue in court. He hired his own time as an operator of a pleasure boat at Point Comfort. Interestingly, some of his descendants later became distinguished faculty and staff members at Hampton, a system he disdained, and his descendant Thulani Davis became a nationally renowned Grammy-winning artist in 1993. (Courtesy of the City of Hampton Museum.)

Two

HAMPTON UNIVERSITY

Education became the vehicle for freedmen seeking autonomy and advancement in the vicissitudes of life. Education would provide the philosophy to govern communities, organize societies, enter into professions of teaching and preaching, and gain access to government. Because Hampton had a large well-educated freedmen population, it became the natural choice for a new normal school.[17] Gen. Samuel C. Armstrong had been the superintendent of the Freedmen's Bureau, and in July 1867, he made a formal petition to the American Missionary Society (AMS), formerly AMA, to establish a school called the Hampton Normal and Agricultural Institute in April 1868. He became the first principal.

The institute was founded on the Wood farm along the Hampton Creek known as Little Scotland. The AMS, Freedman's Bureau, and several private donors provided the $19,000 necessary to purchase a 125-acre farm and its buildings. As a normal school, it taught agricultural and mechanical skills.[18] Armstrong used funds from the federal Justin Morrill Land Grant College Act to wrestle the institute from the AMS. The initial curriculum was focused on vocational training and etiquette lessons in proper attitudes of morality, conduct, temperance, and respect, for Armstrong believed that immorality was a major issue among black people.[19] Interestingly, the advice of educated freedmen in Hampton such as Dr. Daniel Norton, attorney Robert Norton, Thomas Peake, Cary Nettles, Rev. William Taylor, and others was never solicited regarding the chosen curriculum.[20]

Students were briefly interviewed by a teacher and accepted on a trial basis. Early graduates became nationally known for their leadership roles. One of its earliest graduates was the famed Booker T. Washington, future president of Tuskegee Institute and national spokesperson for race-based accommodation. Sarah Collins Fernandis, class of 1882, who wrote the words to the alma mater, became the first black female social worker in the state of Maryland. The same philosophy of educating and giving practical training in the different trades to freedmen was extended to the native people of America.

In 1878, 17 students from the Kiowa and Cheyenne tribes who were prisoners of the 1873 Indian Wars arrived by steamer at the school. A separate American Indian school was established to teach English, and by 1900, over 100 indigenous people had graduated from the school. Armstrong visited reservations and recruited students for the institute, returning home with artifacts and memorabilia that were placed in the college's museum.[21] Despite student health problems and paternalistic attitudes of the Indian Bureau about the co-mingling of two disadvantaged populations, Armstrong assured them that the school's mission had not been hampered. However, black ballplayers were not allowed to participate in basketball games between American Indian teams and local white teams. The same posture existed with American Indians worshipping in white churches and staying in hotels where blacks were denied. This created tension.[22] However, the camaraderie between the two groups prevailed in classroom settings and in campus activities. The government withdrew its financial support of their education in 1912, and records indicate that over 1,300 American Indians from 65 different tribes were educated at the institution by 1923.[23]

Armstrong employed persuasive fund-raising tactics by organizing the Hampton Singers to travel to sing, and by appointing wealthy trustees to the board. Philanthropic efforts resulted in beautiful structures such as Virginia Hall, Memorial Church, the Mansion House,

the Wigwam, Huntington Memorial Library, and the George P. Phenix School, adding a regal touch to the campus. The school was also self-supporting through the general store, light, power, heating, and refrigeration plants, well-stocked farms, steam and hand laundry, and a well-equipped trade school.[24]

The Shellbank Farm was the training ground for students in agricultural skills, and it supplied food for teachers and students on campus. For several years, Ms. Alice Bacon, a white teacher at the college, had become increasingly concerned about the health of freedmen she had been visiting in the neighborhoods around the school. At that time, there was no formal training for black practical nurses in the South. Bacon proposed that a training school for black nurses be established in the Hampton area. The institute donated one of its buildings on its grounds, near the Emancipation Oak and Whittier School, and students converted it into a 10-bed, two-ward hospital. Ms. Bacon named the hospital "Dixie" after the horse she had ridden to visit the sick.[25]

The school for nurses opened with one resident doctor and a superintendent of nurses. The first patient was admitted in May 1891, with subsequent black and white patients. In 1892, the Virginia General Assembly granted the nurses school the formal title of Hampton Training School for Nurses, establishing it as one of the earliest training schools for black nurses in the country.[26] Over 300 nurses had graduated through its last class in 1956. By this time, the college had its own nursing program. Dixie Hospital moved its location to Victoria Boulevard in 1959 and became known as Hampton General Hospital in 1973.[27]

In 1896, the Armstrong-Slater Memorial Trade School offered 11 four-year courses and furnished all-round training in areas including automobile mechanics, blacksmithing, bricklaying and plastering, cabinetmaking, carpentry, painting, steam fitting, plumbing, tailoring, and wheel-wrighting. This school provided the surrounding community with opportunities for business ownership and employment. The demands for skilled tradesmen were high, probably due to the Industrial Revolution. Students learned a trade and developed their minds and characters.[28] It is through the trade school that the black middle class of the early 20th century was created.

In 1906, John Baptist Pierce was appointed by Seaman Knapp and Principal H. B. Frissell of Hampton Institute as the first black farm demonstration agent for Virginia. He served for 35 years as district agent for Virginia and North Carolina and the U.S. Department of Agriculture. His "Live-At-Home and Community Improvement Program" was a unique innovation that helped many people, black and white, raise their standards of living. A history marker of Mr. Pierce can be found on Route 60.[29]

After World War I, college courses were offered, and in September 1923, the school granted the bachelor of science degree in agricultural education for the first time. Formal accreditation as a standard technical and professional college followed in 1927. In 1929, the extension program, headed by the city of Hampton's first black school board member, William Mason Cooper, was primarily established to provide in-service education for teachers, tradesmen, farmers, and homemakers, semi-skilled and unskilled.[30]

Hampton Institute became the official name, and the title of chief executive officer was changed from principal to president in 1930. Dr. George Perley Phenix became president in 1930, and he was the first to hold that title. The high school for the black community during segregation was named after him. Phenix was president for only six months before drowning while swimming.[31] Alonzo G. Moron became the eighth president, and first black president, of Hampton Institute, serving from 1948 to 1959. A 1927 graduate of the school, he administered the dormitory additions, changed the curriculum, phased out agricultural and the trades, established the academic program, addressed ideological conflicts, and provided an intellectual voice regarding school desegregation in Hampton. After his tenure, Dr. Moron returned home to the Virgin Islands and died in 1971.[32]

Dr. Jerome H. Holland became president in 1961, and under his tenure, the university experienced phenomenal growth. Internships, exchange programs, Upward Bound, program

accreditations, and the Early Childhood Laboratory School were reflective of his leadership. Distinguished faculty members such as Dr. Eva C. Mitchell and Dr. Thomas W. Turner had national reputations. Dr. Martin Luther King Jr. addressed the student body under Dr. Holland's tenure, one example of national leaders visiting the campus. During the civil rights movement, students participated in marches, meetings, and sit-ins and desired more choices in academic majors. Dr. Holland led until 1971, accepting the ambassadorship to Sweden by Pres. Richard Nixon. He died in 1985.[33]

Following presidents were Dr. Roy D. Hudson and Dr. Carl M. Hill. Dr. William R. Harvey became president in 1978 and has served the longest in this capacity. At the writing of this historiography, he has served for 27 years. In 1984, under his leadership, the school's name was changed to Hampton University, reflective of the academic curriculum and accreditation status.[34]

This is Gen. Samuel Chapman Armstrong, the first principal of Hampton Normal and Agricultural Institute. As a missionary with the AMA, he petitioned them for support in developing a normal school that would teach vocational training to the freedmen. (Courtesy of the Cheyne Collection, City of Hampton Museum.)

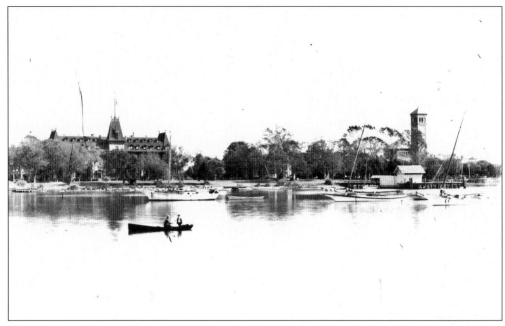

This is a view of the early campus of Hampton Normal and Agricultural Institute in the late 1800s. Notice Virginia Hall, Memorial Chapel, and the riverboats. (Courtesy of the Cheyne Collection, City of Hampton Museum.)

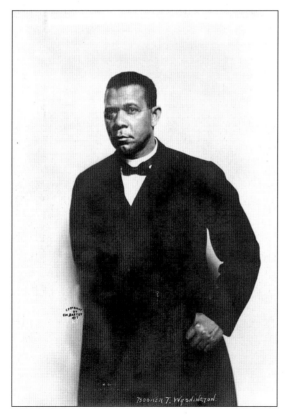

This is Booker Taliaferro Washington, an 1875 honors graduate. He walked 200 miles to the college from Hale's Ford in southwest Virginia. During his interview, he was asked to sweep a room to showcase this ability. He paid his tuition as a janitor. He founded Tuskegee Institute in 1881 and is well known for his political view regarding accommodation and vocational training. His name was considered for Pres. William McKinley's cabinet, but he withdrew his name, preferring to work outside the political arena. Washington died in 1915. (Library of Congress, Courtesy of Prints and Photographic Division.)

Sarah Collins Fernandis is the author of the words to the alma mater. Born in 1863 in Port De Poset, Maryland, she graduated in 1882. Although she wrote poetry, Fernandis is well known for her community development contribution. She founded the first black social settlement house in the United States in Washington, D.C., and was the first practicing black social worker in the state of Maryland. Her career as a social welfare organizer and public health expert in the segregated black communities resulted in her establishing the Women's Cooperative Civic League in Baltimore. It is through this league that she worked for improved sanitation and health conditions in black neighborhoods. She died in 1951. (Courtesy of Hampton University Museum Archives.)

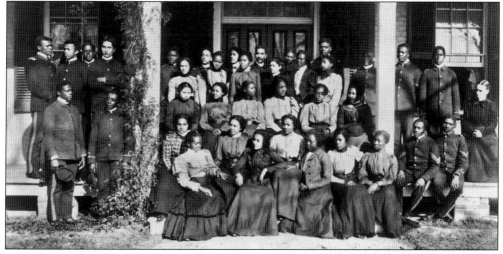

This picture shows Hampton students socializing on the porch in the late 1800s. Notice the advisor on the right observing the students. (Courtesy of Frances Benjamin Johnston/Library of Congress Prints and Photographic Division.)

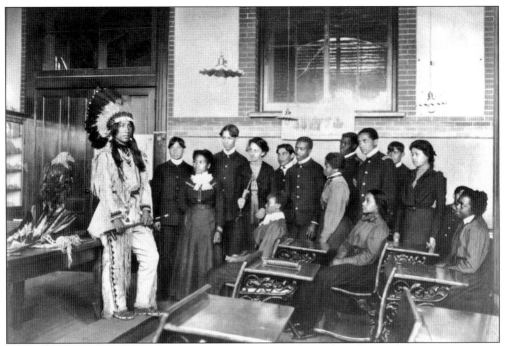

In this picture, Chief Louis Firetail is lecturing to the students. Cultural lessons were exchanged between those students of African descent and students who were indigenous to this land. (Courtesy of Frances Benjamin Johnston/Library of Congress Prints and Photographic Division.)

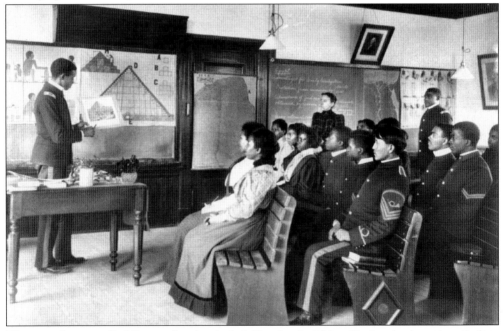

These students studied Egypt, the classical civilization in Africa. Notice the American Indian student in the second row. (Courtesy of Frances Benjamin Johnston/Library of Congress Prints and Photographic Division.)

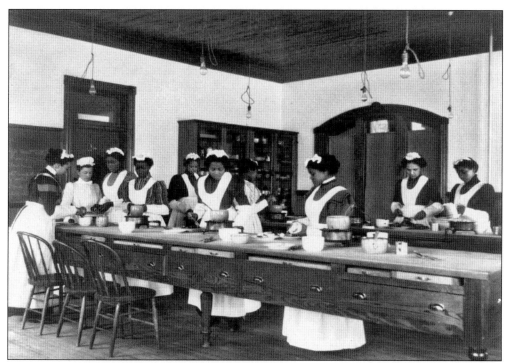

These women learned the art of cooking various meals. Notice their pressed uniforms with the white aprons. (Courtesy of Frances Benjamin Johnston/Library of Congress Prints and Photographic Division.)

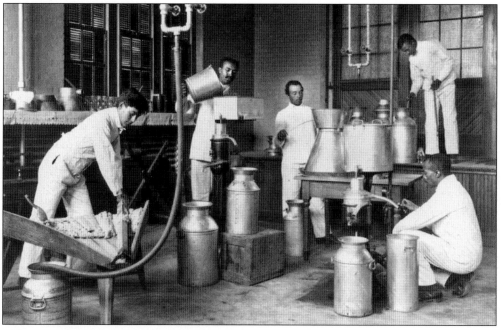

These men are learning how to create and churn butter through special processing. Notice they are dressed in all-white uniforms. (Courtesy of Frances Benjamin Johnston/Library of Congress Prints and Photographic Division.)

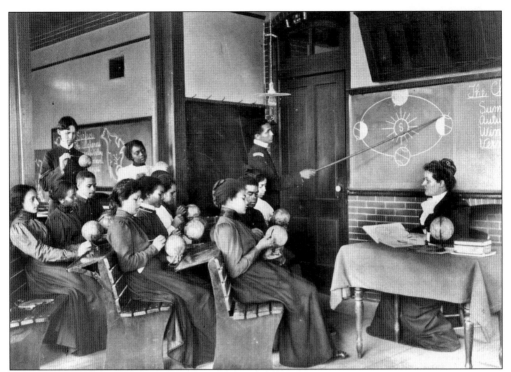
In addition to learning vocations, students learned geography. Notice that each student has a globe. (Courtesy of Frances Benjamin Johnston/Library of Congress Prints and Photographic Division.)

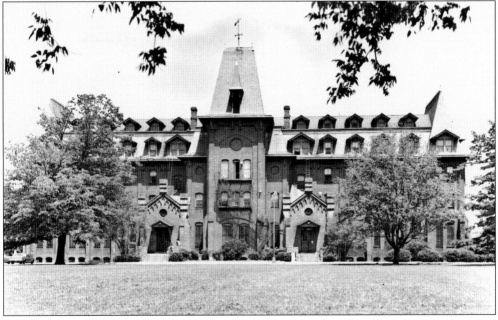
This is Virginia Hall, one of the earliest structures on campus. It has served many purposes, ranging from being a girls' dormitory to housing the printing office and other activities. (Courtesy of Mr. Reuben V. Burrell.)

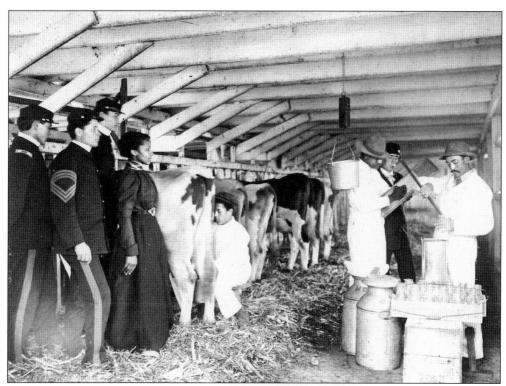

These students are learning the science of milking a cow. Notice they are actually in the barn with the cows and milking instruments. (Courtesy of Frances Benjamin Johnston/Library of Congress Prints and Photographic Division.)

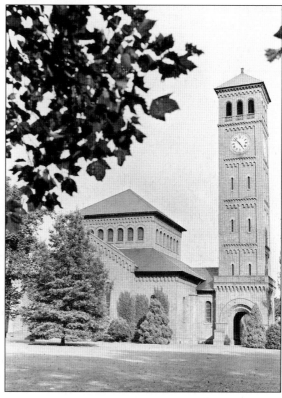

This is Memorial Church, built in 1886. In addition to services and special ceremonies, many weddings of students have taken place in this beautiful edifice. The clock rings at noon everyday. It sits by the water and offers a picturesque and tranquil scene. (Courtesy of Mr. Reuben V. Burrell.)

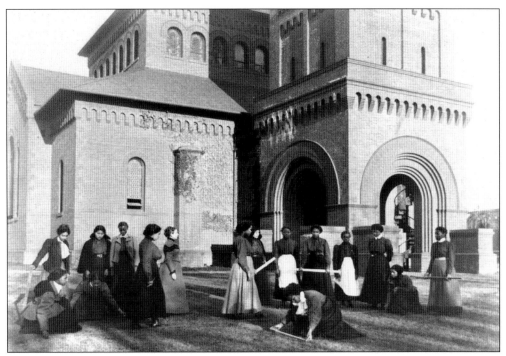
This is an arithmetic class outside of Memorial Church in the late 19th century. Notice the use of rulers to measure the ground. (Courtesy of Frances Benjamin Johnston/Library of Congress Prints and Photographic Division.)

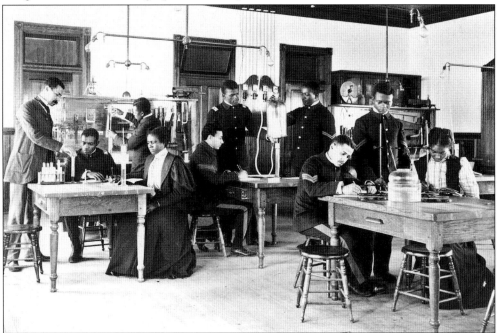
These students are studying capillary physics. Students are using tools to learn the interaction of matter and energy. (Courtesy of Frances Benjamin Johnston/Library of Congress Prints and Photographic Division.)

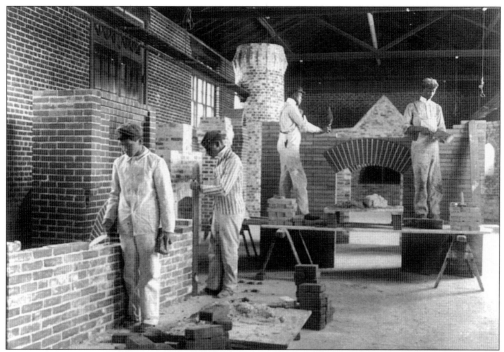

Students are learning the skills of bricklaying. Notice the intricacies of the designs and various types of bricks. (Courtesy of Frances Benjamin Johnston/Library of Congress Prints and Photographic Division.)

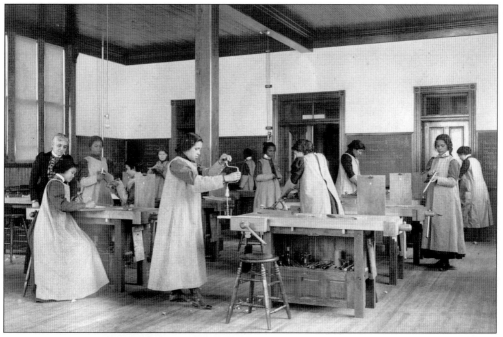

Women's vocational classes were not limited to homemaking and gardening. They also learned the art of building and creating items out of wood. (Courtesy of Frances Benjamin Johnston/Library of Congress Prints and Photographic Division.)

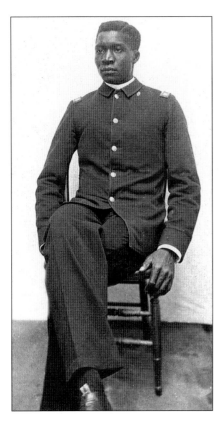

This is Robert Russa Moton, the first commandant of military discipline at Hampton. He was born in Amelia County (Farmville), Virginia, in 1867. He graduated in 1890. In 1900, Moton was elected president of the National Negro Business League and was reelected for the next 20 years. Moton's working relationship with Booker T. Washington began in 1908, when he accompanied Washington on several tours through the Southern states to promote the Hampton-Tuskegee model of racial advancement through vocational education. He succeeded Booker T. Washington as the second principal at Tuskegee Institute in Alabama. The city of Hampton named an elementary school after him. He died in 1940 and is buried in the school's cemetery. (Courtesy of Hampton University Museum Archives.)

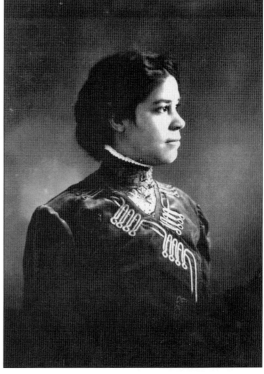

This beautiful woman became Commandant Moton's wife in 1905. Mrs. Elizabeth Hunt Harris of Williamsburg, Virginia, died of an illness in less than two years after their marriage. (Courtesy of the Cheyne Collection/City of Hampton Museum.)

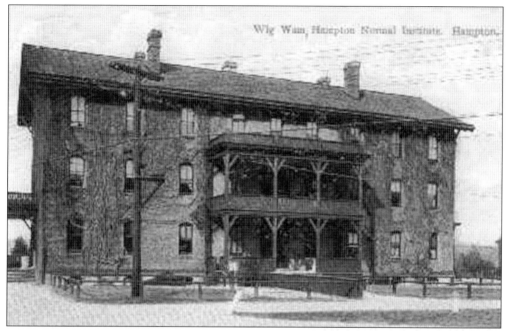

This postcard shows the Wigwam that was constructed in 1878 as a dormitory for American Indian male students. It is now an administrative building. (Courtesy of Historic Hampton Roads, Inc.)

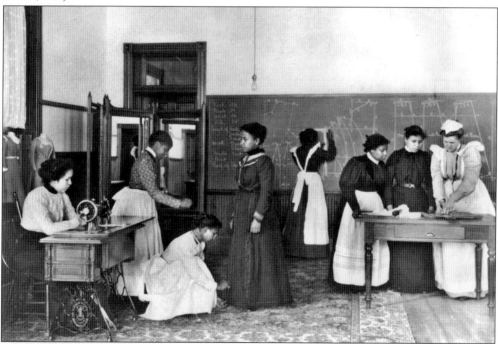

These students are learning the art of dressmaking. Tailor and seamstress were occupations that were vibrant during the early 20th century, and these courses created entrepreneurs. (Courtesy of Frances Benjamin Johnston/Library of Congress Prints and Photographic Division.)

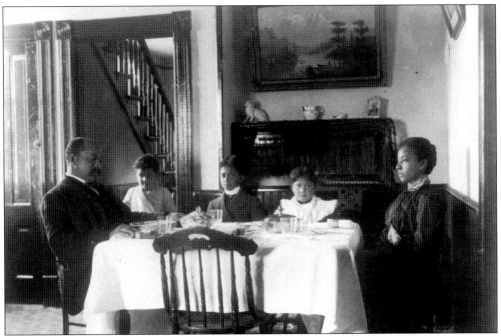

This picture shows a graduate of Hampton Institute and his family. It depicts first-generation middle-class living for blacks around 1900. Notice the piano and the stairs denoting a two-story home. (Courtesy of Frances Benjamin Johnston/Library of Congress Prints and Photographic Division.)

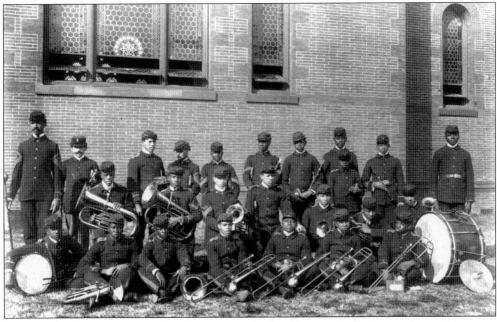

The art of music was always present on Hampton's campus. Every generation at Hampton had a musical group, ranging from the Hampton Singers to bands. This brass band represents those classes of the early 20th century. (Courtesy of Frances Benjamin Johnston/Library of Congress Prints and Photographic Division.)

This is the first Dixie Hospital, formed as a training school for black nurses. (Courtesy of the Cheyne Collection/City of Hampton Museum.)

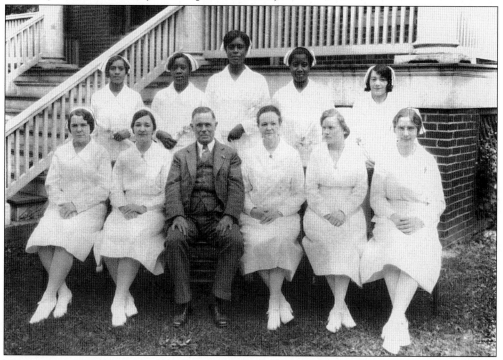
This is an early staff of Dixie Hospital in the late 1800s. The staff consisted of all-white nurses and all-white physicians prior to black physicians joining the staff in the 1940s. (Courtesy of the Cheyne Collection/City of Hampton Museum.)

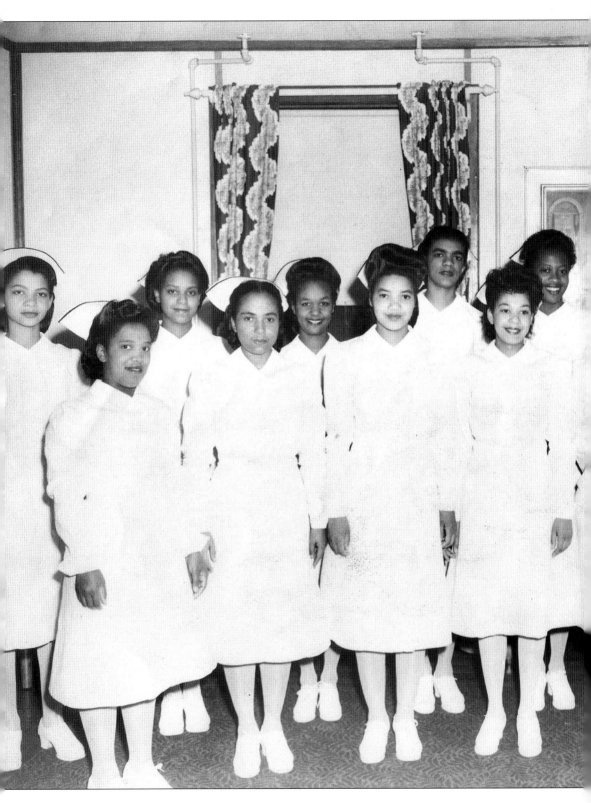

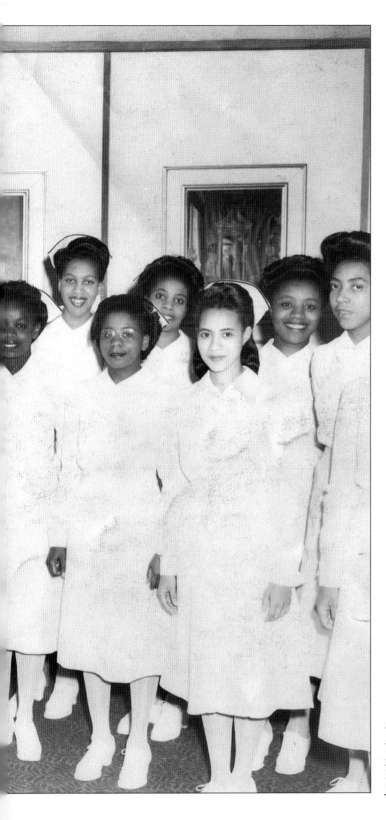

This group of beautiful young ladies is the 1946 graduation class of Dixie Hospital. (Courtesy of Mrs. Julia R. Bassette.)

The *Alumni Journal* was the school newspaper for those early graduates of Hampton Normal and Agricultural Institute. It was in print for several years. (Courtesy of the Chester Bradley Collection/City of Hampton Museum.)

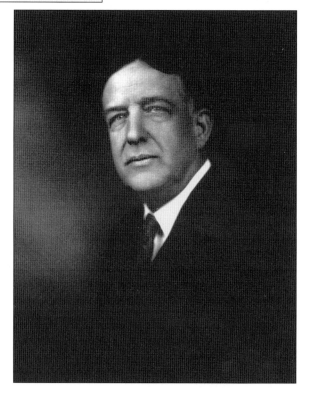

George Perley Phenix was the first president of Hampton Institute. Before Phenix, all previous heads of the school had been principals. Phenix had served the school for 30 years as superintendent to Whittier before becoming president in 1930. He held the post for only six months prior to his death. (Courtesy of the Cheyne Collection/City of Hampton Museum.)

HAMPTON INSTITUTE

ENGINEERING, SCIENCE, AND MANAGEMENT DEFENSE TRAINING

THIS IS TO CERTIFY THAT

CHARLES R. EPPS

HAS SATISFACTORILY COMPLETED A COURSE OF 60 CLASS HOURS IN

RADIO OPERATING SCIENCE

AS AUTHORIZED BY THE UNITED STATES OFFICE OF EDUCATION

AND CONDUCTED BY THIS INSTITUTION

June 4, 1942

ESMDT INSTITUTIONAL REPRESENTATIVE INSTRUCTOR

This certificate was earned through the trade school at Hampton Institute. The trade school offered many courses for the community, enhancing the interaction between town and gown. (Courtesy of Mrs. Lillian Epps Johnson.)

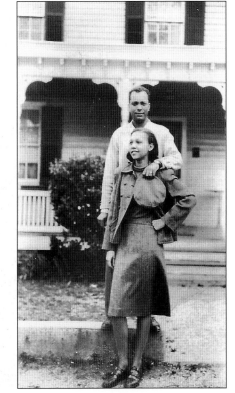

Many children grew up on Hampton Institute's campus as a result of their parents either working there or living in family homes. Here is a picture of Cora Mae Reid and a friend in front of her grandparents' home, Cottage #2, around the late 1930s. (Courtesy of Ms. Cora Mae Reid.)

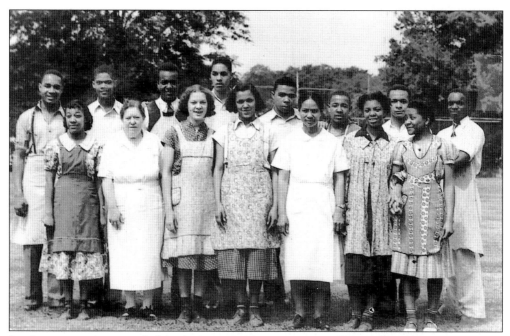

Students were also provided work opportunities on campus. This picture of the dining room crew was taken in 1938. Included in this photograph are Bertha M. Winborne, Ms. Zelma Clark (supervisor), Doris Pope, Hilda Case, Mrs. Roberts, Willie Pearl White, Herbert Birtha, Reuben Burrell, Smith Oliver, and Norris J. "Papa Joe" Banks Williams. (Courtesy of Mrs. Bertha Winborne Edwards.)

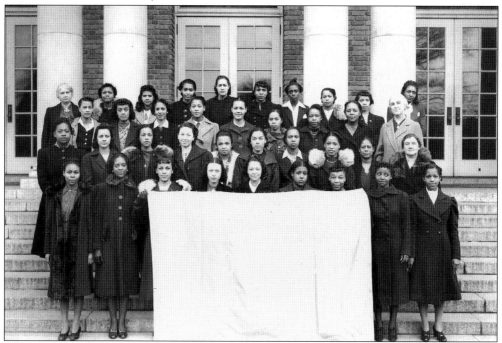

This photograph shows a home economics class of the 1940s. (Courtesy of Clarence and Sadie Curry.)

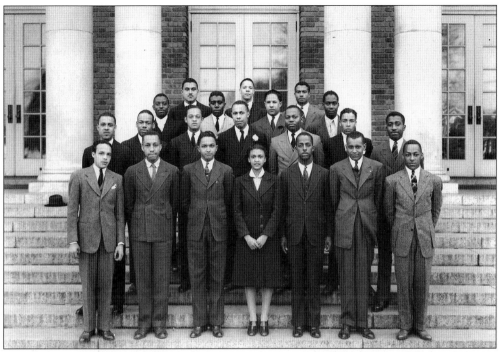

This is the Agricultural Club from 1940–1941. Notice the only female member. (Courtesy of Clarence and Sadie Curry.)

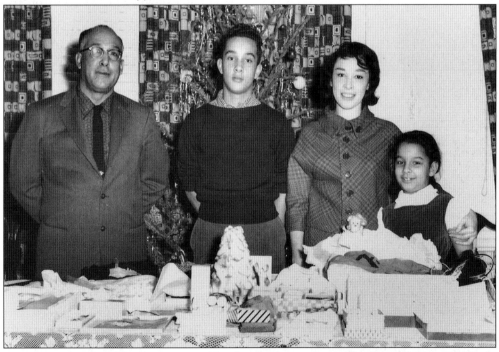

This picture is of Prof. Collis Davis and his family, descendants of William R. Davis. The little girl on the right is Thulani Davis, a 1993 Grammy winner, renown playwright, and author of *1959*, a novel about desegregation in a Virginia town. (Courtesy of Mr. Rueben V. Burrell.)

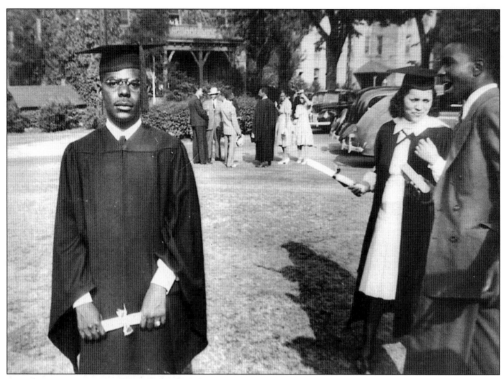

This is graduation in May 1942. Featured here is John D. Nichols of Portsmouth. To the right of the picture is Annie Amos. The Wigwam and Stone building are in the background. (Courtesy of Bertha Winborne Edwards.)

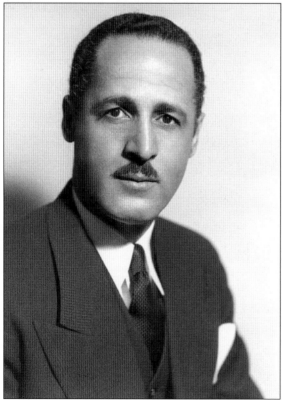

This is the eighth president of Hampton Institute, Alonzo Moron. He assisted the city of Hampton during the school desegregation period and presided over many campus and curriculum changes. (Courtesy of Hampton University Museum Archives.)

This is Dr. Jerome Holland, ninth president. He faced the changes in student attitudes regarding the civil rights movement and Hampton Institute's role in it. He led until 1971, when he became an ambassador to Sweden. (Courtesy of The Daily Press, Inc.)

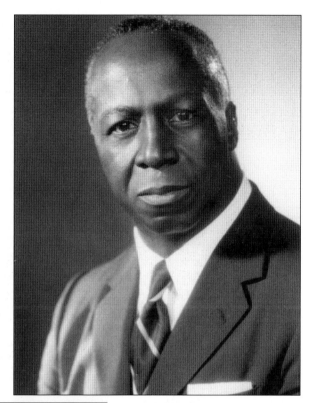

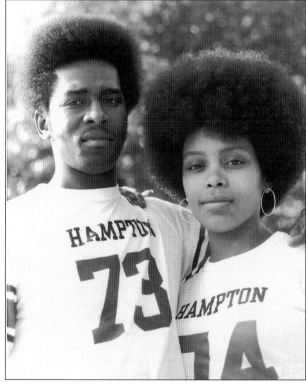

This picture is of Hampton Institute sweethearts, George Jackson and Linda Watson. Taken in 1973 on campus, they have lived up to the saying, "Hampton marriages are made in Heaven," enjoying over 30 years of marriage. (Courtesy of Mr. George Owens.)

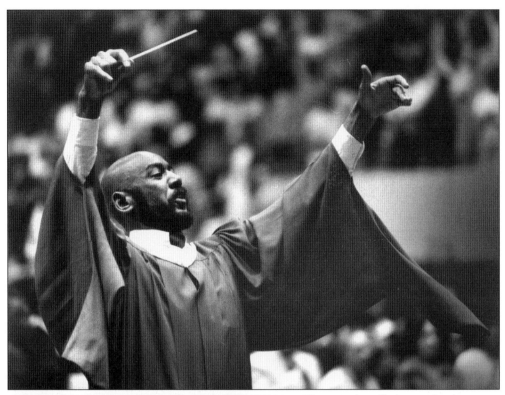

Here, nationally recognized composer Dr. Roland Carter directs the concert choir during the 1979 graduation. (Courtesy of The Daily Press, Inc.)

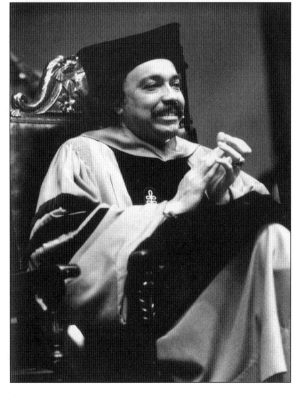

Dr. William Harvey became president in 1978 and is the longest serving in this capacity in the school's history. Known for his impeccable fiscal management capabilities, he has increased the endowment of the school. (Courtesy of The Daily Press, Inc.)

Three

OCCUPATIONS AND THE ENTREPRENEURIAL SPIRIT

The desire to use one's talent and creativity that will sustain family life, have access to collateral and property, and provide means of opportunity for children is the essence of a livelihood. Blacks participated in occupations that were available to them post-enslavement, such as crabbing, oystering, fishing, farming, cleaning clothes, and landscaping. They became shoemakers, sailors, bakers, brick masons, seamstresses, midwives, waiters, painters, woodcutters, washerwomen, blacksmiths, domestic workers, and teamsters. They did contracting work where opportunities were available. Seafood processing became an important industry in Elizabeth City County. Hundreds of blacks worked for James McMenamin, J. S. Darling & Sons, J. H. Jarvis Packer & Shipper of Crab Meat, L. D. Amory & Company, L. M. Newcomb Fishing Fleet, Watkins Crab Plant, and S. S. Coston Company. Blacks such as Henry Armistead and John Mallory Phillips owned oyster grounds, allowing them to have a piece of the seafood industry.[35] Hundreds of blacks worked for the Newport News Shipyard and the C & O Railroad. The Hygeia Hotel, renamed the Chamberlain, was a popular employer of blacks.

During Reconstruction (1865–1890), professional blacks included teachers, social workers, principals, ministers, undertakers, physicians, politicians, and lawyers. Rev. Richard Spiller (First Baptist), Rev. William Thornton (Zion), Rev. Thomas Shorts (Queen Street), Rev. H. P. Weeden (Wine Street), Rev. L. D. Lively (Ebenezer), Warren and Andrew Smith of Smith Brothers Funeral Home, attorneys A. W. E. Bassette, George W. Fields, George Washington Fields—also known as "the blind lawyer," Luke Phillips, and Dr. Thomas Addison were formidable names of men who contributed in these leading occupations.

As the 19th century came to a close, owning and controlling a business was the quintessential sign of independence and upward mobility. There were hundreds of black-owned businesses in Elizabeth City County that created the first black middle class during Reconstruction. The black business community was so varied that any product or service desired was obtained from a black merchant.[36] The black business district was from the beginning of Queen Street to west of Liberty (Armistead Avenue), and from King Street northward. Businesses such as Thomas Harmon's Groceries and Dry Goods, Kate Williams Dry Cleaning, Richard Palmer's Dry Goods Store and a blacksmith shop, the butcher shop of Walter Hickman, and the furniture store of David Pratt lined Queen Street.

The People's Building and Loan was on King Street next to First Baptist Church, probably because Rev. Richard Spiller, its third pastor, was a co-founder of the bank.[37] The bank was founded on March 4, 1889, and lasted for 102 years. Mr. Isaac Johnson and Mr. A. W. E. Bassette were on the first board. The Galilean Fishermen's Consolidated Bank was also on Queen Street, and it had an endowment and printing department, headed by Queen Street Baptist Church's pastor Rev. Thomas Shorts. Smith Brothers Funeral Home, the wood and coal companies of William Nelson and P. J. Taliferro, Dr. Thomas Addison (physician), and the *County Journal*, edited and published by Sara Banks, were at the corner of Lincoln and King Streets.

Social work was a growing occupation that concentrated on the development of institutions of help. These institutions were businesses that engaged in "child-saving"—a service primarily devoted to the care and development of children. Janie Porter Barrett, an 1884 Hampton Institute graduate, formed the Locust Street Social Settlement in 1890. This settlement had a child welfare department that provided guidance for young mothers and children through adolescence. As an advocate for children, Barrett appealed to a judge to send an eight-year-old child to the Weaver Orphan Home rather than jail. Barrett lived at the home at the time.[38] She was a recognized statewide leader because she was a founding member of the Virginia State Federation of Colored Women's Clubs in 1908, an organization that is still in existence today, headquartered on Pembroke. The Virginia Industrial Home School for Colored Girls that she started received its first residents in 1915 in Hanover County, Virginia, and the school is now named for her. She is buried in Elmerton Cemetery.

From 1904 to 1965, the Weaver Orphan Home provided a refuge for orphans and widows on their 25-acre farm on West Queen Street (now McDonald's Nursery). Rev. W. B. Weaver and his wife, Mrs. Anna Belle Weaver, accepted orphans and supported the farm through donations from merchants, grocers, and other businesses. Mrs. Weaver graduated from Hampton Institute in 1881 and met Reverend Weaver through her brother, who was his classmate. Her husband had established the Gloucester Training School and also founded the Cappahosic Academy prior to settling down in Hampton. Hundreds of children have come through "a land of hearts desire," the Weaver Orphan Home.[39]

The YMCA, headed by Luke Phillips, James A. Fields, and George Davis, was another social organization that was prominent in the life of the community. The ladies of the town organized the United Order of Tents, a Christian society dedicated to aiding the sick and elderly.[40] Mrs. Sallie B. Fields opened a community center at King and Mallory Streets in the early 20th century, providing a place of refuge, kinship, and opportunity for many children. There were several other smaller entities in communities that reached out to those families struggling to survive. The extended family structure enabled multiple generations to easily reside under one roof and embraced close friends to experience the love and support of family, while achieving educational and occupational goals.

The 20th century established Virginia's segregationist policy in all areas of life—housing, education, business, etc. The community responded by establishing businesses that the community patronized. In turn, business owners were able to reinvest their money into the community and support their families. There were two black pharmacists, William Parker and Robert S. Boyd Sr. Both men finished the 1921 School of Pharmacy at Columbia University. Parker's business, Langley Pharmacy, had a gymnasium, a soda fountain dinette, and meeting places. Boyd Pharmacy was a family business. Their relationship with black physicians was a partnership. Many an evening, either would receive a call from a physician who needed a prescription filled immediately. They would not only fill the prescription, they would also deliver it to the patient.

Another business that could be found in the "black district" was the Lyric Theater, which was replaced by Basie Theater. These theaters featured popular black films, singing groups, and bands. Other businesses that filled the business district included W. T. Anderson Dry Goods Store, Abraham Lively Grocery Store, "Shack" Walker's Taxi Cab and Restaurant, Garnett Walker—auto dealer and mechanic, Matilda Evans—beautician, Barney Walker's Famous Crabcakes, Fred Chisman Confectionary and Shoe Shine, Harry Holmes Cleaning Store, Shelton Davis Confectionary Store, James Bell Cleaners and Taylor Shop, Franklin Shoe Repair Store—The Blue Ribbon Shoe Shop, Williams Barber Shop, R & H Filling Station, Yeoman Dining Hall, Yeoman Barber Shop, Lyles Service Station, Hicks & Wallace Tailoring, Jacob Williams—High Class Tailoring, Merritt Hope—The Bicycle Man, Owens blacksmith, and Modern Shoe Rebuilders, Spratley Radio & T.V. Service, Glen's Barber Shop, Fauntleroy's Barber Shop, Willie Morgan Service Garage, and the Savoy Hotel.

There were popular restaurants—The Manhatten, which had a recreational facility attached to it and was run by James and Sam Frances; The Flamingo; The Rush, run by Mr. and Mrs. Earnest Henderson; and The Silver Candle Dinette, owned by Mrs. Elvira Barbour.

Union Street housed Pinner's Grocery Store, Bailey's Store, and Suburban Gardens Restaurant. In Phoebus, there was the Rendezvous Restaurant, Manning & Evans Music Corp., D. D. Askew—Fine Shoe Repairing, Blair B. Perry—Merchant Tailor, Don Down's Shoe Repair, Sam Bailey Store, Harriett's Frozen Delights, Isaac Johnson's General Merchandise Store and Real Estate, The Family Barber Shop, Turner's Confectionary Store, the Majestic Inn, and Horton's Café & Hotel.

Pembroke Avenue had the Auto Mart; Fred Whiting Photography; Grand Terrace, Barney Walker, proprietor; Garden City Scrap Iron & Metal Company; Reliable Caterers; James Kirkpatrick Jr., tailor; Walter "Nucky" Wray of Nucky's Open Air Market and Taxi Business; T. A. Fountain Upholstery; Harriet's Drive-In; John D. Williams of Wingate Beauty and Barber Supply Dealer; Abraham's Taxi Cab & Restaurant; and Webster's Open Air Market.

Other businesses were Alfred Sexton's grocery stores, one on Back River Road and the other on Rip Rap Road. Mr. Ulysses Martin Sr. had a sawmill in Back River for 30 years. Mr. Martin ran a logging operation and sold lumber to white companies. He built homes at cost and cut out streets using equipment that was horse-drawn. He employed over 20 black men with most contracts. Mr. Leonard Powell was a fisherman. He had his own boat and sold seafood. Newsome & Son Transfer Company specialized in moving and was located in Lincoln Park. Mr. Asa Sims was the first black florist in Hampton. He owned Sims' Florist. There was also Perry's Garage and Paul Frances Grocery.

In addition to Smith Brothers Funeral Home, there were several other funeral homes. There was W. H. Satisfield Funeral Home, and a lady mortician named Mrs. Mattie Corbin Vann, who worked for Charles H. Jones Funeral Home. Ronald Perkins Funeral Home replaced Satisfield. Also, there were two black dairies, one owned by Henry Clapps in Old Northhampton and the other by London Sexton in Back River.

Professional services included physicians such as Dr. William S. Hart (dentist), Dr. Henry A. McAllister (dentist), Dr. Burl Bassette, Dr. Andrew Bassette III, Dr. Anderson T. Scott (surgeon), Dr. Thomas P. Davis, Dr. Maurice Frazier, Dr. William Lloyd, and attorneys Inez Fields Scott, A. W. E. Bassette Jr., and William Alfred Smith. Real-estate agent Stuart Whiting provided insurance, while Lawrence Barbour provided accounting and financial services for this business and several others.

These businesses were financial and professional resources assessable to the community through desegregation. Although the Housing and Urban Development Act and the New Communities Act of 1968 provided repayments to businesses affected by urban renewal, those businesses were not provided sufficient start-up capital to relocate. The government regarded many of these businesses to be mom-and-pop situations and provided only the minimal commercial repayment. The Housing and Community Development Act of 1974 obliterated these business districts, along with neighborhoods, family life, and schools. These businesses acted as a collective fiscal base that provided a function for the development of human behavior, values, and upward mobility. Urban renewal policy was intended to provide safe housing and modernize conditions. However, urban renewal removed home ownership, a financial base, and the personal familiarity that money can never buy.[41] The financial collateral the black community in Hampton lost has never been calculated or regained, and many generations bore witness to the totality and magnitude of such loss.

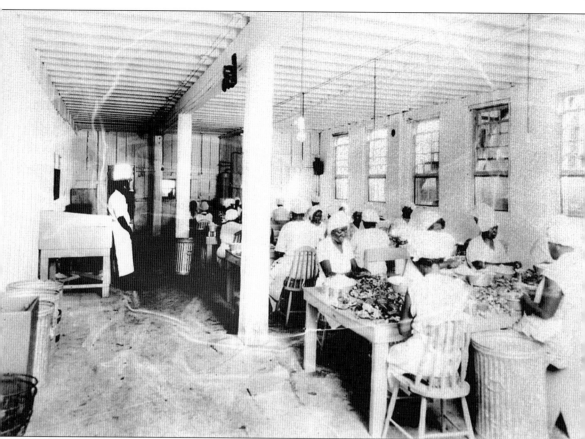
These women are workers at the C. C. Coston Company. Many of them picked crabmeat for a living and supported their families. (Courtesy of the Cheyne Collection/City of Hampton Museum.)

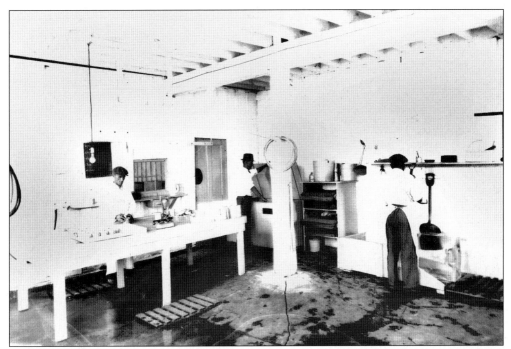

This picture shows men working at the Watkins Crab Plant. These and other workers helped create the booming seafood industry Hampton is known for. (Courtesy of the Cheyne Collection/City of Hampton Museum.)

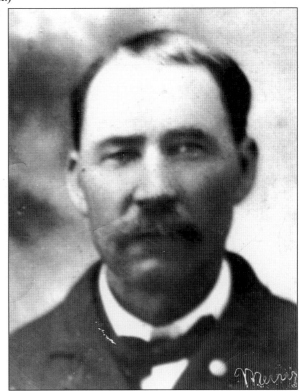

This is John Mallory Phillips I, who founded his own oyster bed. (Courtesy of Mrs. Josephine H. Williams.)

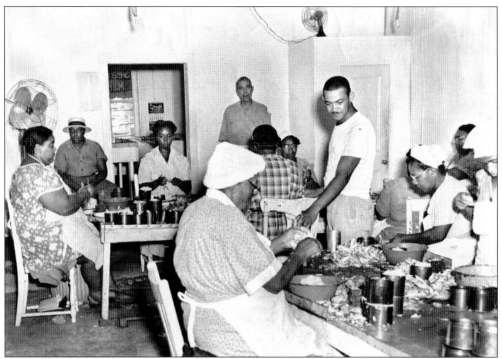
John Mallory Phillips, a descendent of John Mallory Phillips I, was able to continue the family tradition and was one of two blacks participating as owners in the seafood industry. In this photograph, he is watching workers in his factory. (Courtesy of Mrs. Josephine H. Williams.)

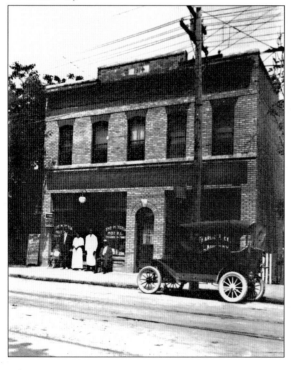
Blacks also worked at the Hygeia Hotel, providing domestic and janitorial work. (Courtesy of the Cheyne Collection/City of Hampton Museum.)

The Peoples Building and Loan Association was founded in 1889 and had the distinction of being the first black bank of the community. Rev. Richard Spiller was its first president. Its office was next to First Baptist Church on King Street. It served the community for over 100 years. (Courtesy of the Cheyne Collection/City of Hampton Museum.)

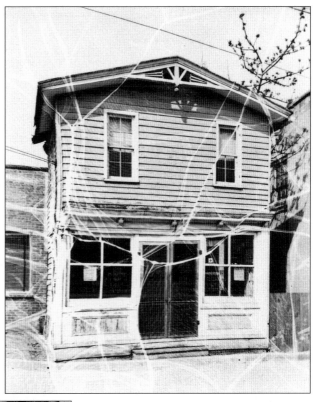

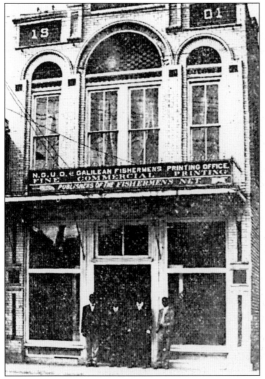

Galilean Fishermen's Consolidated Bank was founded in 1901. It also had an endowment and printing shop. The founder was the pastor of Queen Street Baptist Church, Rev. Thomas Shorts. Reverend Shorts also served as vice president of Peoples Building and Loan. (Courtesy of the Cheyne Collection/City of Hampton Museum.)

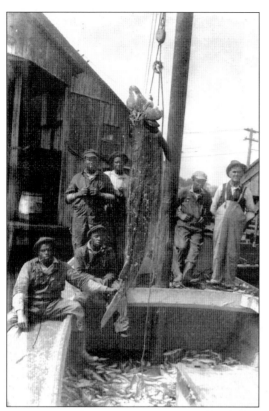
Here are men with a huge sturgeon. Many black men were fishermen, selling the fish caught for their own profits, or hiring themselves out to other companies. (Courtesy of the Cheyne Collection/City of Hampton Museum.)

Black women worked as domestics, often because many other opportunities were not available to them. Students at Hampton Institute took courses in homemaking to capitalize on jobs to raise their families. (Courtesy of Frances Benjamin Johnston/Library of Congress Prints and Photographic Division.)

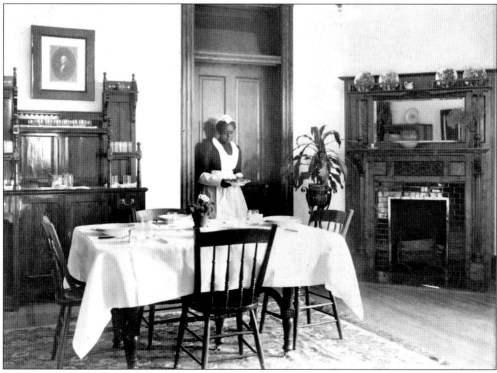

This is Warren Tyler Smith, founder of W. T. Smith Funeral Home. He was born in 1830 in Charles City County and started the business in Hampton in 1862, on Hope Street. As his sons joined the business, the name became known as W. T. Smith and Sons' Funeral Home. In 1930, after his death, the business moved to West Queen Street and became known as Smith Brothers. Due to urban renewal, the family business moved to Mercury Boulevard in 1971, where it is located today, five generations later. (Courtesy of Smith Brothers Funeral Home.)

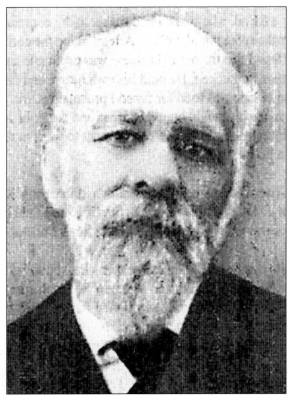

This is one of the first business vehicles for W. T. Smith Funeral Home. (Courtesy of Smith Brothers Funeral Home.)

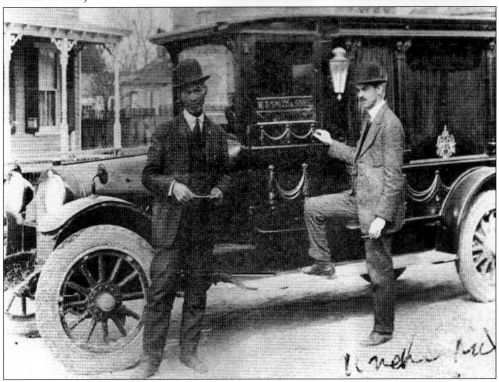

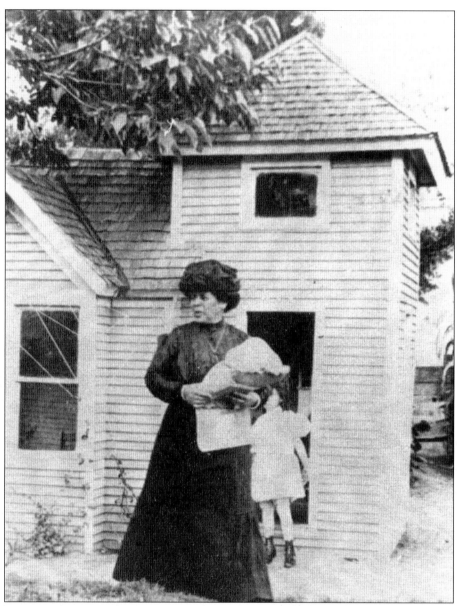

This is Janie Porter Barrett. A 20th-century mover and shaker, she has a statewide legacy in social work. An 1882 graduate of Hampton Normal and Agricultural Institute, she formed the Locust Street Social Settlement in 1890. She is shown here in front of the settlement with an infant in her arms. Barrett also founded the Virginia Industrial School for Colored Girls that is now named for her. A contemporary of Sarah Fernandis, Maggie Walker, Nannie Burroughs, Ida Barbour, Virginia Randolph, and other statewide influential black women who created change in American society in post-Reconstruction, she founded the Virginia State Federation of Colored Women's Clubs in 1908. This organization helped her in providing appropriate environments to raise children, rather than have them placed in institutions of loss, such as jails and almshouses. A special feature of her work was that each resident had a bank account. Upon discharge, the resident had money to take with them. (Courtesy of the City of Hampton Museum.)

This is Rev. W. B. Weaver and Mrs. Anna Weaver, founders of the Weaver Orphan Home in 1904. This home provided a "land of hearts desire" for orphans and widows who could not provide for them. The Weavers created the Gloucester Training School in neighboring Gloucester County, and the Cappahosic Academy on their farm, also in Gloucester. Born in enslavement, Anna Woodson Weaver grew up in Cumberland County, Virginia. Her husband, Rev. W. B. Weaver was born a freeman in North Carolina. He met Anna's brother at Hampton Institute, and he and Anna married. Many orphans grew up to become teachers, business owners, and community leaders. The Weaver Orphan Home closed in 1965. Weaver Street in Aberdeen Gardens is named for Reverend Weaver. (Courtesy of Mrs. Lillian Williams Lovett.)

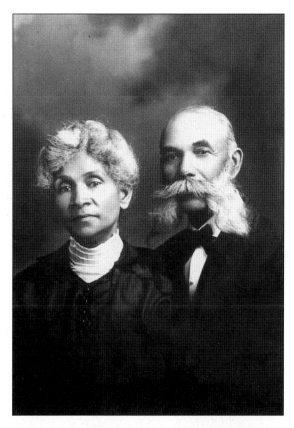

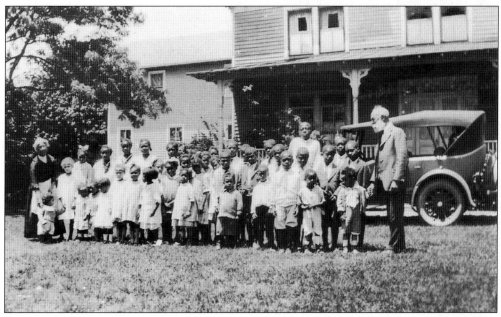

This is Reverend and Mrs. Weaver with some orphans on their farm. (Courtesy of Mrs. Lillian Williams Lovett.)

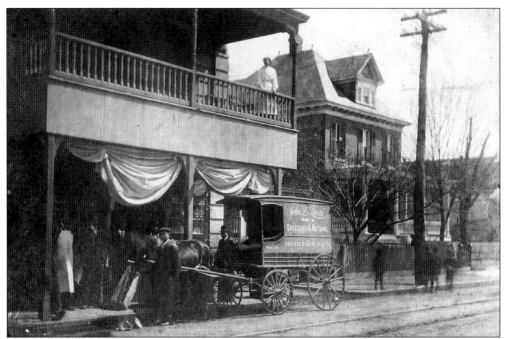

This is the Lively Market that was located on King Street, across from First Baptist Church. The market was owned by brothers John and Abraham Lively. The house located on the right was owned by the sister of Mr. Warren Smith, of W. T. Smith Funeral Home. (Courtesy of Mrs. Edith Lively Hamlin.)

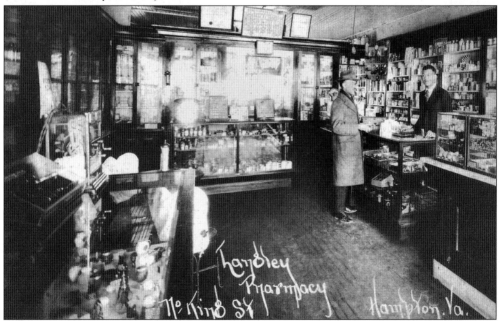

Langley Pharmacy, owned by William Parker, was the first drugstore that provided the community with medicinal needs in 1923. In addition, it offered a soda fountain, a dinette, and a meeting place for organizations. William Parker finished Columbia University, School of Pharmacy, in 1921. (Courtesy of Ms. Aurelia Parker.)

This is the outside of Langley Pharmacy on Queen Street. Over the store was a seven-room apartment. (Courtesy of Ms. Aurelia Parker.)

Mr. Robert S. Boyd Sr. owned Boyd Pharmacy on King Street. It opened in 1931 and operated for 32 years. He finished number four in the class in the same 1921 School of Pharmacy class with William Parker. They were colleagues and partners, owning a store in Norfolk as well. (Courtesy of Mrs. Gail Boyd Jones.)

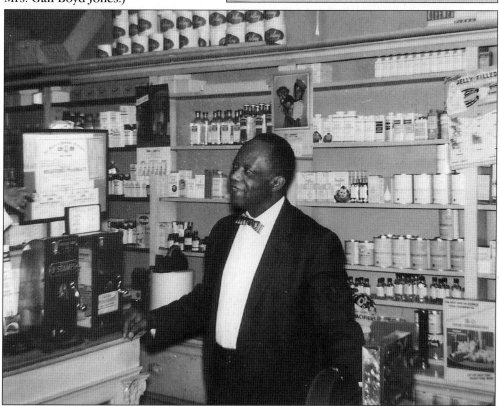

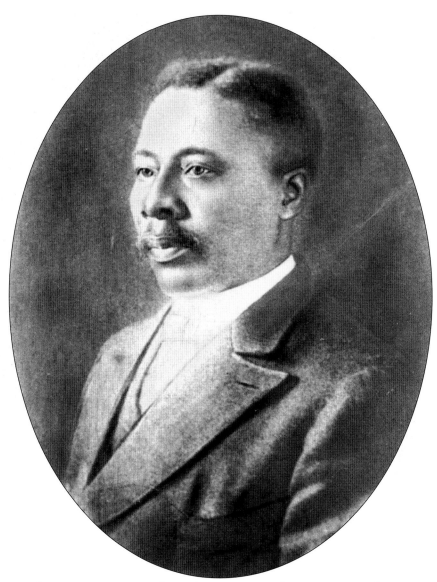

Andrew William Ernest Bassette, shown here, was a teacher, attorney, and property owner in Hampton and Newport News. Born in 1865 and raised in Elizabeth City County, he graduated from Hampton Normal and Agricultural Institute in 1876. Bassette married Ida Diggs in 1884 and had six children. As a teacher, he opened a two-room school on Back River. He also tutored pupils in his law office for many years. Bassette was a founder of the Peoples Building and Loan Association, serving as attorney for the bank for many years. He purchased a building and named it the Bassette Academy, which served as a theater for plays, concerts, and other shows. His work as a trustee of First Baptist Church served the church well. On one occasion, he walked to Williamsburg to conduct business on behalf of First Baptist. His children would make him proud; A. W. E. Jr. became an attorney, Burl Bassette became a physician, and Edward Bassette became a dentist. His grandson, A. W. E. III, would also continue this family name and legacy and serve the community as a physician and civic leader. In 1971, the city of Hampton named the A. W. E. Bassette Elementary School after this giant. (Courtesy of Mrs. Julia R. Bassette.)

Mrs. Elvira Barbour owned the Silver Candle Dinette, Hampton's Premier Caterer. She had a wonderful reputation for preparing delicious meals. Mrs. Barbour also catered for wealthy whites. (Courtesy of Mrs. Catherine T. Barbour.)

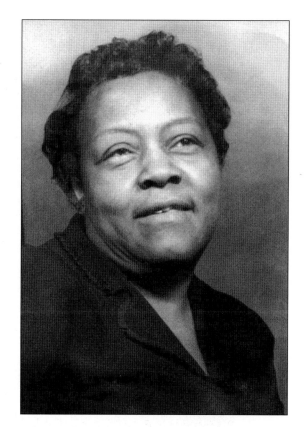

This is Lawrence Barbour, accountant and financial expert. He was in the first graduating class of Phenix High School in 1932 and finished Hampton Institute in 1936. Barbour managed many businesses, taking care of the books, taxes, and other fiduciary matters. Barbour started the Citizen's Organization that provided support to black city workers. Barbour also helped found The Beau Brummells, a civic and social organization, in 1941. As a longtime trustee at First Baptist Church, his accounting skills were greatly utilized. He was the son of the premier caterer, Mrs. Elvira Barbour. (Courtesy of Mrs. Catherine T. Barbour.)

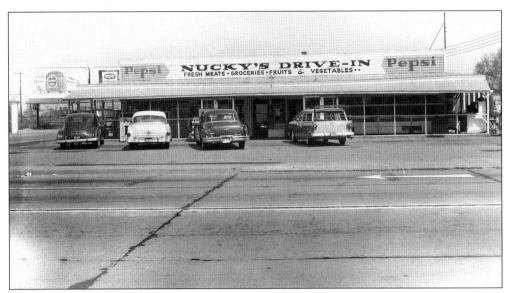

This is Nucky Wray's Open Air Market. The proprietor, Walter Wray, offered the community quality items that many black farmers sold to him. He also owned a taxi business. (Courtesy of Mr. Rueben V. Burrell.)

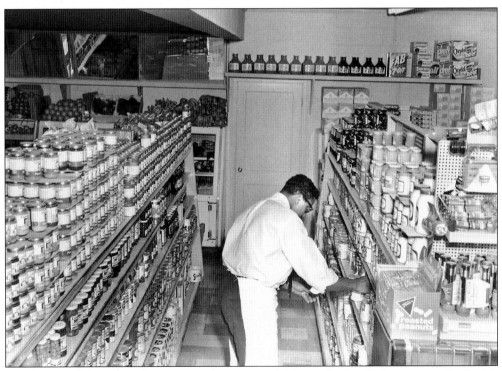

This is the inside of Nucky Wray Market. Notice how neatly the shelves are stacked with products. (Courtesy of Mr. Rueben V. Burrell.)

This is Asa Sims, who owned Asa Sims Florist on Woodland Road. The greenhouse was attached to the family home. As a horticulturalist, he owned the only black floral business in Hampton. He also taught in the trade school at Hampton Institute. (Courtesy of Mrs. Jannette Sims Cooper.)

This is Ulysses Martin Sr. He owned a sawmill and logging operations and sold lumber to big white companies. He also built Martin Ville in the early 1920s. (Courtesy of Mrs. Louise Martin Webster.)

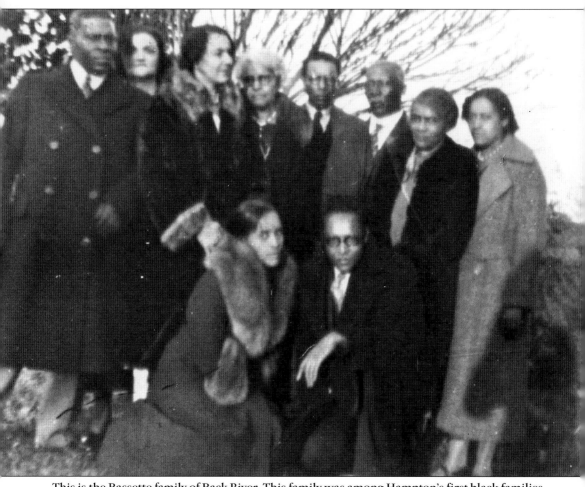

This is the Bassette family of Back River. This family was among Hampton's first black families. They are, from left to right, as follows: (first row) Laura and Dr. Edward; (second row) Dr. Burl, his wife, Undine, Mrs. Phoebe, Mrs. Ida D., attorney A. W. E. Jr., A. W. E. Sr., Mary, and Louise. (Courtesy of Mrs. Julia R. Bassette.)

Four

BUILDING COMMUNITIES

Community represents the synergy of history, family, friends, church, and business. Prior to desegregation, the black community in Hampton had neighborhoods that allowed one to identify who you were, your family, and often your church. Olde Hampton and Lincoln Park, Semple Farm, Back River, Old Northhampton, Newtown, Phoebus, Aberdeen Gardens, Buckroe, Garden City, Dunbar Gardens, and Thomas Villa are representative of neighborhood elements of history, family, friends, and church, and a financial arm. These communities were self-sustaining, with various socioeconomic classes. Newtown, Phoebus, and Buckroe were integrated neighborhoods.

Olde Hampton is very near to where the Grand Contraband Camp resided after the Civil War. Streets called Union, Liberty, Lincoln, and Grant were named by Olde Hampton's original contrabands. Located in downtown Hampton, Olde Hampton was in close proximity to the thriving black business district. Many remember the beautiful old homes and trees that lined the streets with manicured lawns. First Baptist Church, Bethel A.M.E. Church, and Queen Street Baptist Church provided spiritual instruction and community outlets. The Pee Dee (P.D.) section, a smaller section near what is known as Mill Point, included Wine Street (now Third) Baptist Church. Lincoln Park was a section of Olde Hampton.

Usually, loved ones were buried in cemeteries adjacent to neighborhoods. Phillips Cemetery, between Union and Lincoln Streets, is in Olde Hampton. Elmerton Cemetery is also in Olde Hampton, on King Street across from the Greyhound Bus Station. Bassette Cemetery, named after the A. W. E. Bassette family, is on Pembroke Avenue behind the Greyhound Bus Station. There is Smith Cemetery on Woodland Road in Phoebus. George Washington Carver Memorial, now known as Hampton Memorial Gardens, is located on Butler Farm Road. In addition to neighborhood cemeteries, there were many church cemeteries as well, and the Hampton University Cemetery near the Veterans Administration. Since cemeteries were developed within communities, they now serve as markers that communities once thrived there. At any time one could see old mayonnaise jars with flowers in beautifully decorated plots. Also, plots may have been covered with pieces of broken dishes or a picture of the deceased.

The Semple Farm Road was a community inhabited by many families right after the Civil War. Semple Farm is near the Shellbanks farm near Langley Field. It is also in close proximity to the spot where the Battle of Big Bethel took place during the Civil War. The community created the Semple Farm School, with notable teachers such as Ms. Nanny King, Ms. Lela Truheart, and Mrs. Mable Harrison. Ebenezer Baptist Church served the community, and the reservoir was their baptismal pool. Persons were identified by family names such as Lovett, Presson, Jordan, Russell, Stewart, Wynder, Smith, Barber, Bailey, Combs, Cross, Day, Bordon, Veney, Lester, Banks, Nettles, Braxton, Barker, Johnson, Garrow, Washington, Brown, and Howard.[42] Ebenezer Baptist Church cemetery is located on Semple Farm Road.

The Back River community included those first families: Lively, Sexton, Turner, Collins, Bassette, Martin, Brandon, Courtney, and Johnson.[43] Families on Butler Farm Road were removed when the white owners returned after the Civil War. However, Gen. Benjamin Butler turned the confiscated farmland over to the families.[44] There was a Back River School. London Sexton owned Sexton Dairy in Back River.

The Morning Star Baptist Church served families on Butler Farm Road, Back River, and Semple Farm. The church had a bell in its steeple that would ring, summoning worshippers on Sunday morning. Original family names of Morning Star Church include Watts, Davis, Pritchett, Francis, Cross, Hudgins, Shields, Kitchens, and Hawkins. George Washington Carver Cemetery was where loved ones were buried; it is now known as Hampton Memorial Gardens.

Old Northhampton is located on Rip Rap Road and was once referred to as "Over the Dike" by whites. The latter terminology made reference to a dike that crossed the Hampton Creek, built as a walkover. The community church was Bethel Christian Church, later known as Bethel United Church of God in Christ. The church would have spirited revivals and concerts, sponsoring renowned groups such as the Harmonizing Four, The Mighty Clouds of Joy, and the 5 Blind Boys of Alabama. Clapps Dairy was located in Old Northhampton.

The Newtown Community, an integrated neighborhood on Ivy Home Road off of Kecoughtan, is popular because the Historic Little England Chapel is located there. A white farmer from New York named Daniel Cock purchased 148 acres of land near what is Little England. Black men Charles Smith and Edward Whitehouse purchased the 100-acre King's Farm in 1867, adjacent to Cock's property. Gen. Samuel C. Armstrong's brother, Col. William Armstrong, bought 165 acres, including a parcel called Black Bears located at the entrance of Hampton River adjacent to the Cock, Smith, and Whitehouse properties. In 1869, David Cock divided a 35-acre triangular section into 33 lots to sell to freedmen. A surveyor titled the parcels Cock's Newtown. Simultaneously, blacks had purchased lots from Charles Smith, Edward Whitehouse, and Colonel Armstrong. Early family names were Pressey, Johnson, Savage, Parker, Jones, and Washington.[45] Newtown is present-day LaSalle Avenue, south of Victoria Boulevard.[46]

Phoebus was another community where blacks resided. Although there wasn't an exclusive section, many blacks lived on Booker Street, Woodland Avenue, and Old Buckroe Road. Black businesses in Phoebus were located where Zion Baptist Church sat to County and Mellon Streets. The Buckroe-Phoebus Women Service League Social Club and the Modernistic Club provided assistance to the community as well.[47] Another integrated section of Elizabeth City County was Buckroe. Antioch Baptist Church was the center of a close-knit community in Buckroe. Many persons who lived in these sections, and attended either Zion or Antioch, were baptized at Bay Shore, the black-owned beach/resort.

Aberdeen Gardens was completed in 1937 as a subdivision built by blacks for blacks. Under Pres. Franklin Roosevelt's New Deal Plan, in 1934 the Federal Farm Security Administration and Hampton Institute (University) accepted the responsibility. Aberdeen Gardens was designed by Howard University architect Hilyard Robinson, who supervised the team of bricklaying students from Hampton Institute. The original model included brick residences from five to seven rooms adjacent to the Johnson farm. Every home had a chicken coop and enough yard for a garden. The street names are after significant African Americans who have contributed to the progress of the race: Paul Mercer Langston, the first president of Virginia State University and a U.S. Congressman in Reconstruction; Mary Peake, a schoolteacher; Maggie Lena Walker, the first female banker (black or white) in the country; James S. Russell, founder and president of St. Paul's Normal Industrial School (College); Daniel L. Webster Davis, minister, teacher, lecturer, and poet; Matthew N. Lewis, pioneer black journalist and founder and publisher of *Newport News Star;* and Rev. W. B. Weaver, founder and director of Weaver Orphan Home.[48]

Aberdeen elementary school–age children attended Aberdeen Gardens Elementary School. It was placed on Virginia's Historic Landmark Register and the National Register of Historic Places in 1994. Little Zion Baptist Church was well-attended by Aberdeen residents. Granger Court, an adjacent subdivision, was built in the 1950s. It was named after Lester B. Granger, who was the first national president of the National League, and a Hampton Institute (University) trustee. He was also special assistant to the secretary of the navy in the 1940s.

Mr. Ulysses Martin created a subdivision called Martin Ville, located at Rowe and Thomas Streets, Rip Rap Road, and Langley Avenue.[49] Garden City and Dunbar Gardens were communities developed off of Shell Road post–World War II in the 1940s. Both of these communities created more homeownership opportunities for blacks. Mimosa Crescent, Suburban Parkway, and Gayle Street were popular cul-de-sacs that were developed in the 1950s.

Thomas Villa was the last developed all-black neighborhood in Hampton. P. Floyd Thomas Sr. and Helen Clark Thomas of Alabama purchased 10 acres from the Middleton family. During the late 1950s and early 1960s, banks in Hampton were not investing in black homeownership, so the Thomases contacted C. C. Spaulding Insurance Company in North Carolina, a black-owned company. The company financed some of the loans so that families could build homes. The neighborhood became a cul-de-sac on C. C. Spaulding Drive, in honor of the insurance company. About 20 extensive ranchers with attached garages graced the mix of socioeconomic classes including ministers, teachers, a shipyard employee, a NASA employee, and a barber. The Thomases also developed other properties: Clark Villa, Bonds Villa, and Thomas (TNT) Apartments in Hampton. Unfortunately, Thomas Villa was shattered by the city's proposal to use that land as a part of an entertainment development. After some property was sold, the city altered its plans to use the land. Only a few residences and vacant lots remain.

The neighborhoods highlighted represent the best in what communities offered families: history, values, and support, coupled with spiritual instruction and fiscal institutions. Blacks created these beloved neighborhoods in the pursuit of homeownership, as opposed to being forced into neighborhoods by discriminatory whites.[50] Persons of great character were produced from these neighborhoods well into the late 20th century such as Hazel Reid O'Leary, secretary of energy; Belinda Tucker-Houston, Texas judge; Thulani "Barbara" Davis, Grammy winner, author, and playwright; Steve Riddick, 1976 Olympic medalist; Shaun Gayle, NFL star; Allen Iverson, NBA star; Marcellus "Boo" Williams, founder of the Boo Williams Summer League, Invitational Tournament; and Gerald Kerry, CIAA director. Mr. Irving L. Peddrew III became the first black student admitted to Virginia Tech in 1953. His admittance broke racial barriers in higher education, as he was the first black student admitted to an all-white land-grant institution in the former Confederacy. He was the only black student out of 3,322 students at Virginia Tech.

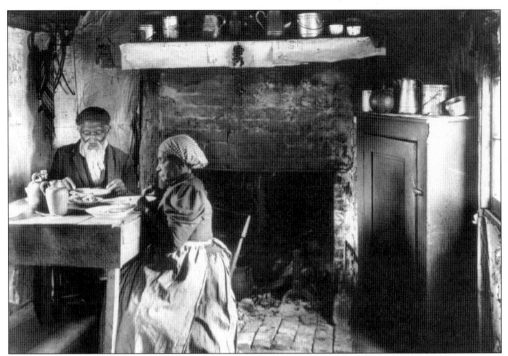

This early picture shows the beginning of community life. This couple is eating in their one-room home. (Courtesy of the Francis Benjamin Johnston Collection/Library of Congress Prints and Photographic Division.)

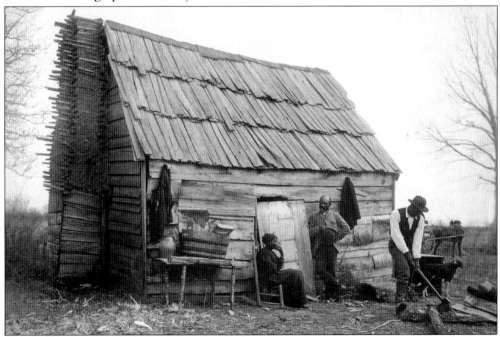

This cabin was an early replica of homes found in communities in the late 19th century. (Courtesy of Frances Benjamin Johnston/Library of Congress Prints and Photographic Division.)

This picture is of the Reid brothers, Leon, William, and Thomas Reid, c. 1890. They grew up on Hampton's campus. Leon became a dentist in Richmond, William taught in Hampton Institute's trade school, and Thomas became a popular attorney in Portsmouth. Dr. Leon Reid's son, William Ferguson Reid, was the city of Richmond's first black state representative to be elected to the house of delegates post-Reconstruction. (Courtesy of Ms. Cora Mae Reid.)

These dapper young men could be seen walking to and from school and running errands for their families in their communities. (Courtesy of Courtesy of the Cheyne Collection/City of Hampton Museum.)

This is the William and Dinah Clark Mann family of Phoebus. (Courtesy of Mr. and Mrs. Clarence Curry.)

This is the Hubbard family of Phoebus. They lived on Frissell Street. (Courtesy of the Estate of Ms. Elaine Hubbard Cooke.)

This handsome couple is Vernon and Myrtle Brown Courtney of the Back River community. (Courtesy of Mr. and Mrs. Ivan Courtney.)

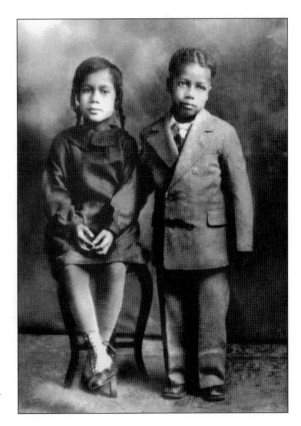

These adorable children are Thelma and her brother Frederick Gary in the late 1920s. They grew up in Olde Hampton. Their family attended First Baptist Church, which was within walking distance of their home. Also within walking distance was the Union Street Cemetery, where their mother was buried in 1927. (Courtesy of Mrs. Thelma Gary Boone.)

This Masonic meeting was typically held in a neighbor's home or in a section of a restaurant. (Courtesy of Mrs. Louise Walker Simpson.)

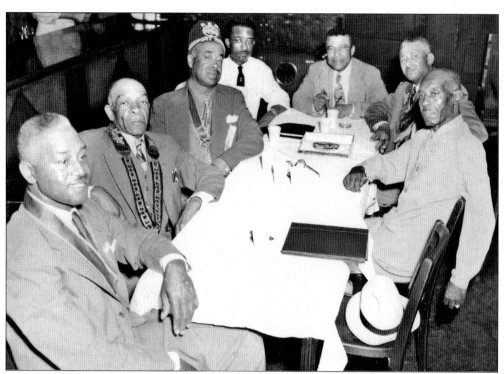

Charles Rogers Epps learned how to operate his own radio station in Old Northhampton. Many neighbors listened to noteworthy events via radio in one another's homes before the advent of the television. (Courtesy of Mrs. Lillian Epps Johnson.)

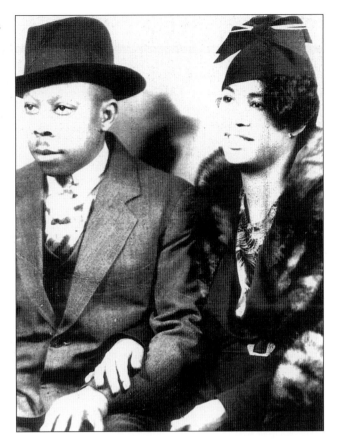

This handsome couple, Charles and Maggie Keyes Jones, was the first couple to move into Aberdeen Gardens in November 1, 1937. They grew to be pillars of the community and of Little Zion Baptist Church. The missionary circle there is named for Mrs. Jones. She was the historian of the neighborhood, keeping every neighborhood birth, marriage, and other memorabilia in a book. If someone was injured or sick, she attended to him or her. (Courtesy of Mrs. Margaret Wilson.)

This is one of the first homes in Aberdeen Gardens. This neighborhood was built for blacks by blacks. Hampton Institute students were the builders. These homes had connecting garages. (Courtesy of the Cheyne Collection/City of Hampton Museum.)

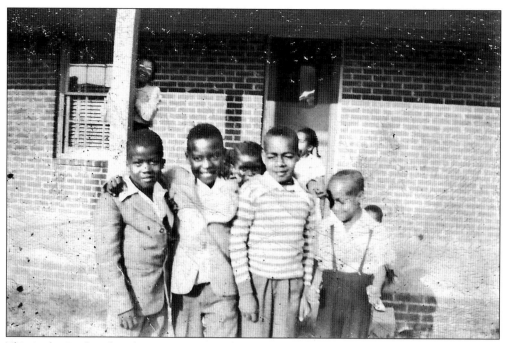

This is the Paul and Violet Diggs Cary household on Langston Street in Aberdeen Gardens. (Courtesy of Mr. Howard Cary Sr.)

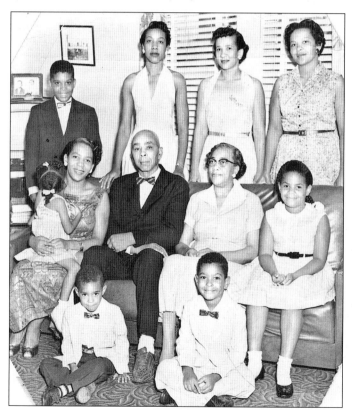

This is the Lively family of Back River, c. 1956. From left to right are as follows: (front row) Dana and Thomas Nottingham; (second row) Lillian L. Stafford (holding Doris Stafford), Alphonso and Carrie Sexton Lively, and Patricia Nottingham; (third row) Wilkins Stafford, Pearl L. Bailey, Ellen L. Bolling, and Jessie L. Nottingham. (Courtesy of Mrs. Ellen Lively Bolling.)

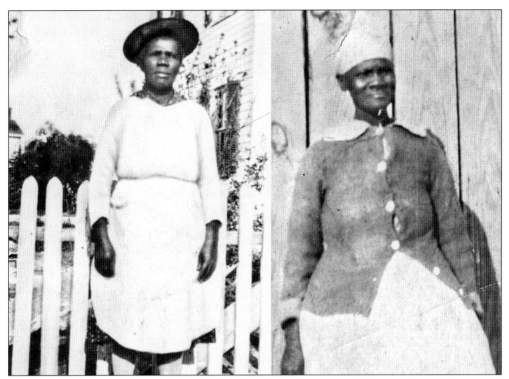

This is Mrs. Ida Smith Wynder standing in front of the Wynder home place on Semple Farm Road. Her mother, Mrs. Elizabeth Banks Smith, was a midwife in Semple Farm and surrounding communities in the late 1800s and early 1900s. (Courtesy of Mrs. Celestine Wynder Carter.)

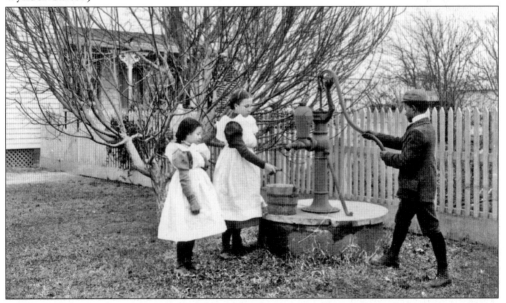

This scene was very common in many neighborhoods at the turn of the 20th century. Here, children are pumping water in Newtown. (Courtesy of the Cheyne Collection/City of Hampton.)

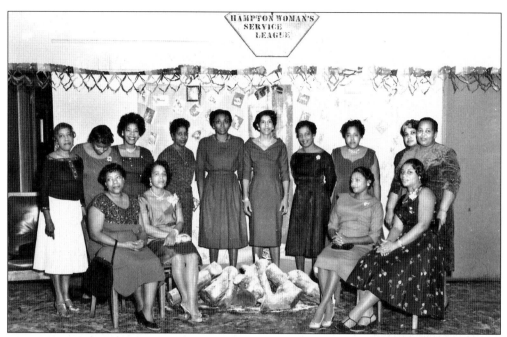

This is the Hampton Women's Service League, c. 1960. This was a civic and service organization that assisted with community disasters, contributed to charities and worthwhile causes, and provided immeasurable support to the bereaved. The ladies lived within the neighborhoods highlighted in this chapter. (Courtesy of Mr. Rueben V. Burrell.)

This is Secretary of Energy Hazel Reid O'Leary, who served under Pres. William Clinton. She spent her early years in Aberdeen Gardens and attended Aberdeen Gardens School. (Courtesy of the U.S. Department of Energy.)

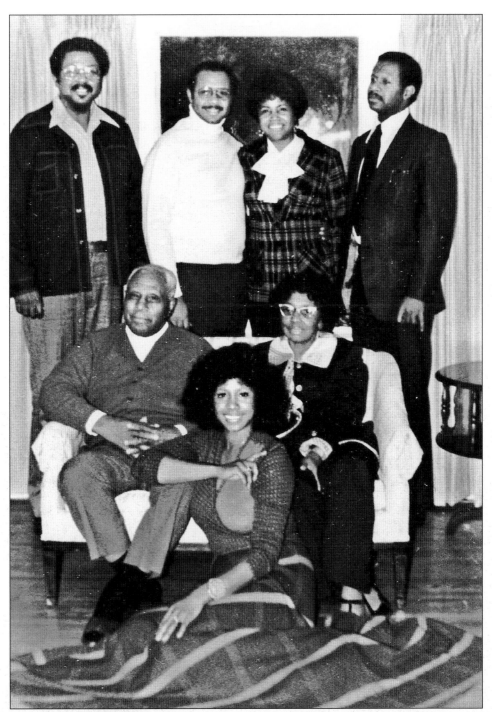

This is the Thomas family of Thomas Villa, c. 1960. They are as follows, from left to right: (front row) Mr. P. Floyd Sr., Ms. Mary Helen, and Mrs. Helen Thomas; (back row) Dr. John, P. Floyd Jr., Dr. Henrietta T. Dabney, and Dr. William. Mrs. Helen Thomas and P. Floyd Sr. developed Thomas Villa at C. C. Spaulding Drive and several other properties. (Courtesy of Ms. Mary Helen T. Jackson.)

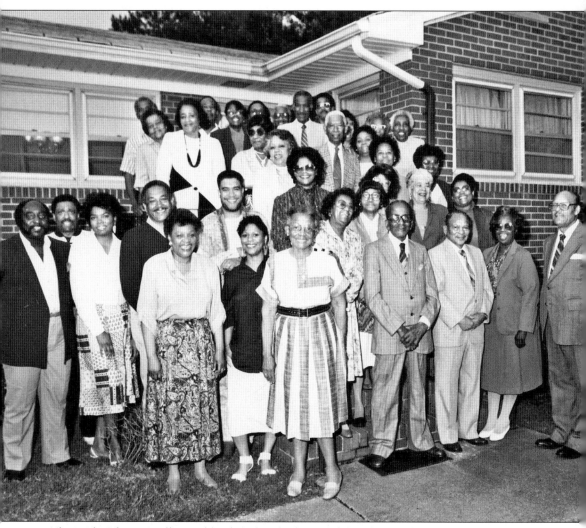

This is the Thomas Villa neighborhood at the home of the Thomas family. Each home would host the neighborhood dinner meeting, and in 1988, this picture was taken at the home of Mrs. Helen Thomas, who is front and center. (Courtesy of Mrs. Hattie Thomas Lucas.)

This is Shaun L. Gayle, who grew up in Aberdeen in the 1960s and 1970s. He played football for Bethel High School and Ohio State University. Gayle played professional football as a strong safety for the Chicago Bears for 11 years, between 1984 and 1995. He was co-captain of the 1985 Super Bowl team. (Courtesy of Mrs. Delores A. Gayle.)

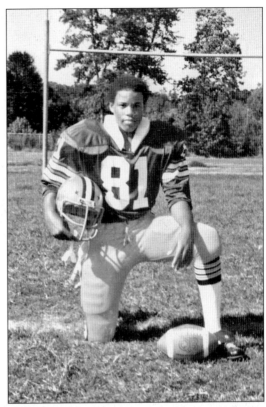

Local hero Marcellus "Boo" Williams grew up in Phoebus. He excelled in basketball at Phoebus High and St. Josephs University. He started the 1982 Boo Williams Summer League, a non-profit athletic organization, and has influenced developmental ideas of using team organizational experiences to emphasize the importance of education, teamwork, work ethic, and appropriate sportsmanship. Founded by a living icon, the summer league has cultivated local talent into national sports contributors such as Tajama Abraham, Aaron Brooks, Terry Kirby, Alonzo Mourning, Chris Slade, and Bryant Smith. (Courtesy of Mr. Charles Brown).

Marcellus "Boo" Williams and Mr. Howard White are pictured at an annual banquet of the league. White played basketball for Kecoughtan High School and was All-American at the University of Maryland. White is currently vice-president of Brand Jordan, Nike. (Courtesy of Mr. Charles Brown.)

This picture is of Allen Iverson, who grew up in Aberdeen Gardens and completed Bethel High School and Georgetown University. Despite hardships, he has succeeded in becoming a leading scorer for the Philadelphia 76ers. Ms. LaKeisha Frett played basketball for Phoebus High School and the University of Georgia and is a dominating player for the WNBA's Sacramento Monarchs. Both outstanding players are products of the Boo Williams Summer League. (Courtesy of Mr. Charles Brown.)

Five

SERVING GOD, SAVING SOULS

Religious instruction has always been vital in the lives of black people. Hampton is a microcosm of what one will find when studying cultural aspects of community. Churches were the center of community life, because members lived in close proximity to the church, and other types of programs were held at the church in addition to services. There were eight black churches in Hampton by the 1880s: six Baptist, one African Methodist Episcopal (A.M.E.), and one Protestant Episcopal. This number would grow as the 20th century unfolded.

As a member of one of these churches, one obeyed the moral and social structures laid down by their congregations and ministers. Positions attained in church like deacon, trustee, superintendent of Sunday school, etc., acquired great status in the community at large. This system operated independent of one's economic and educational position in the wider society.[51] A unique aspect of this history is that many churches shared pastors, thus creating more cohesiveness within the community.

The First Baptist Church was organized in 1863. Black parishioners worshipping in the white Hampton Baptist Church sat in the balcony. The Rev. Zechariah Evans served as their first pastor for about three years. The second pastor, the dynamic Rev. William B. Taylor, was born into enslavement as Billy Colton, but took the surname Taylor. The church grew and settled on North King Street. Phenomenal ministers have headed this church, thrusting the church into a leadership position with the establishment of the People's Building and Loan Association, where Rev. Richard Spiller, the third pastor, served as the bank's first president.[52] Rev. Dr. J. W. Patterson stabilized First Baptist well into the 20th century, serving as pastor for 49 years.

Zion Baptist Church on County Street was also organized in 1863. They first met in a humble dwelling put together by slabs. In 1871, the American Missionary Association sold the church a half acre of land in the amount of $80. Frank Diggs, Harry Armistead, and Abraham Chisman were appointed trustees to hold the legal title for the benefit of the church. Rev. William Thornton served the church until 1909. A very influential pastor of Zion was the Rev. J. Dett Marshburn, who pastored Zion for 35 years (1937–1972), and also pastored Antioch, located at Wine Street and Lebanon in neighboring Surry County. Many baptisms of Zion Baptist Church occurred at Bay Shore. Marshburn ran for city council several times, never winning. He was known to be a "people's pastor."

The A.M.E. Church is one of the largest Methodist groups in the country. Formed in 1787 by Richard Allen and Absalom Jones in Philadelphia, it has hundreds of sister churches. In 1864, the Bethel A.M.E. Church was organized by six members, including Fr. Peter Sheppard. Services were held at Camp Hamilton near Tabb's Field. Later in 1871, the group built a house of worship on Oak Street (now Wine Street). The first brick church was erected on Lincoln Street in 1887. During its early history, Bethel organized two churches: Butlers Farm A.M.E., which ceased to exist shortly afterwards, and Ebenezer A.M.E. Church

in Phoebus, which was destroyed by fire. Rev. Roscoe Wisner was a noted pastor in the Hampton community and served Bethel for many years.[53]

Founded in 1865, Queen Street Baptist Church was initially known as Second Baptist Church, because its founding members were from First Baptist Church of Williamsburg. The church is a landmark in downtown Hampton and has a distinctive early history. Rev. John Smith served for 16 years, and Rev. Ebenezer Byrd served for two years and then helped start the Ebenezer Baptist Church on Semple Farm Road in 1884. Rev. Thomas H. Shorts served from 1883 to 1917. Under his leadership the church experienced phenomenal growth. He founded the Galilean Fisherman's Consolidated Bank, which had an endowment and printing department that was started in 1904. He also became vice president of People's Building and Loan. Reverend Shorts was regarded as a spiritual teacher. Under his ministry, several "sons of the church" were ordained and founded other Hampton churches: Rev. H. L. Austin, founder of Lincoln Park Baptist Church in 1912, now First Baptist Church, Lincoln Park; Rev. Lester Doc Lively, pastor of Ebenezer Baptist Church; and Rev. John H. Gray, founder of Gray's Missionary Baptist Church. Rev. George Russell pastored this church for 31 years (1935–1966), developing a variety of boards and organizations. He was truly a renaissance pastor, due to his civic activism in many other associations.[54]

Little England Chapel was built between 1878 and 1880 by Hampton Institute students. It served as the center of the Newtown community, hosting programs, concerts, meetings, and informal gatherings. It was originally known as the Ocean Cottage Sunday School. Hampton Institute students regularly offered Sunday school lessons here to the black community in Newtown from the early 1880s into the 20th century. The Newtown Association acquired the property in 1954, under the leadership of Mrs. Mary Johnson and Mrs. Oceola Ailor. In 1981, it was listed with the Virginia Landmarks Register and with the National Register of Historic Places in 1982.[55]

Wine Street Baptist Church was organized in 1881. The founding members were originally from First Baptist. Rev. Henry P. Weeden was its first pastor. This church had many activities, including plays that often occurred at the Lyric Theatre. In addition to Reverend Marshburn, Rev. Isom Gilbert Gladden Sr. pastored for over 30 years (1937–1970). The church's permanent name became Third Baptist Church. As with the other churches, Third Baptist had the Baptist Young Peoples Union (BYPU), church school, vacation bible school, new member orientation circles, and missionary circles. Thomas Harmon, the first black councilman during Reconstruction, was a member.[56]

The visionaries who, in 1884, organized Ebenezer Baptist Church were Srs. Jennie and Keziah Presson, Sr. Maria Strong, Br. William Russell, Rev. John Lovett, Rev. Henry P. Weeden, and Rev. Ebenezer Byrd. Rev. Lester D. Lively was called to pastor and did so from 1889 until 1937 when he died. For 48 years, he was very influential in the life of the Semple Farm community. Baptisms took place in the reservoir. Rev. George S. Russell pastored for 26 years (1939–1965). He was also pastor of Queen Street Baptist Church during this time. Organizations such as the Willing Workers, choirs, and usher boards flourished under both pastorates.[57]

The Little Zion Baptist Church was organized in 1885 from a prayer band in the home of Deacon Burl Parker. The first pastor elected was Rev. G. W. Thornton. In the early years, Deacon Cornelius Jones was chair of the deacon board, and Deacon Silas Guthrie chaired the deacon and trustee boards. This church served many families with farms in the North Hampton area, as well as some families from Aberdeen Gardens.

The Buckroe Beach community welcomed Antioch Baptist in 1895. The founders who organized Antioch were from Zion and Queen Street Baptist Churches. Rev. William N. Thornton, first pastor of Zion, also became the first pastor of Antioch. Reverends Joseph Brown, J. E. Tynes, Oliver A. Brinkley, and J. Dett Marshburn pastored this church as well.[58]

Each year, a union revival was held, and converts went to the churches of their choice. In 1896, Morning Star Baptist Church converts decided they wanted a church in the

Shellbanks, Back River, and Butler Farm communities. Rev. Lester Doc Lively, who resided in the community, was chosen to be the first pastor. He was also pastoring Ebenezer and Bethel Baptist Churches. The first three trustees, Mr. Lewis Lively, Mr. William Hooker, and Mr. William Perry purchased a half acre of land from Mr. John Shepherd. Morning Star has had long pastorates: Rev. A. A. Hill pastored for 39 years (1898–1937) and Rev. Richard J. Brown pastored for 36 years (1938–1974).

The only black Episcopal Church, St. Cyprians, was organized in 1905, originally established as a mission of Richmond's St. John's Episcopal Church. The 10 original members included Mr. and Mrs. Richard Phillips, Mrs. Mary W. Cardwell, Mr. and Mrs. Edward Spennie, Mrs. Lottie Fairfield, Mr. and Mrs. Charles S. Miller, Mrs. Cora Beamon, and Mrs. Mary Santa Cruz. Rev. Ebenezer H. Hamilton became the first rector. The first church was erected on Lincoln Street. This church has a history of impressive orators. Vicar Walter D. Dennis, who served the church between 1960 and 1965, became canon-in-residence at the Cathedral of St. John the Divine in New York City and was consecrated Bishop Suffragan of the Diocese of New York on October 6, 1979. Father Baxter, who served between 1978 and 1984, became dean of the Washington National Cathedral. [59]

Bethel Christian Church was started in 1914 by Rev. A. B. Ellis. The first church was in a storefront on King Street. Land was later purchased for construction on Rip Rap Road. The church became the only one in Old Northhampton. There were 20 members when the church first opened it doors to the community.[60] This church was known for hosting nationally-renown singing groups as well as its delicious dinners afterwards.

The Church of God of the Gospel Spreading Church, Inc., was established in Hampton in 1922. Elder Lightfoot Solomon Michaux was a radio evangelist who started an old-fashion gospel tent revival on Grant Street that drew hundreds of people in many cities throughout the East Coast, including Newport News. Elder Michaux was known as the "Happy am I" preacher. His radio broadcast started in the mid-1930s and ran until his death in 1968. The community tuned into WJSV (now WTOP) to hear the broadcast. Elder Michaux was personal friends with Presidents Franklin Roosevelt and Dwight D. Eisenhower and other dignitaries.

Riverview Baptist Church served the Dunbar Gardens community on Hannah Street. Many churches moved into Hampton, although they were originally from neighboring counties. An example is the Sixth Mount Zion Baptist Church, founded in 1900 in Newport News by Rev. N. E. Nelson and Missionary Baptists from Charles City County and Richmond. This church moved to Kecoughtan Road in 1976 and has grown significantly, now having several thousand members. It is now on Mercury Boulevard and is renamed Sixth Mount Zion Baptist Temple. These and other churches established later would provide spiritual support to the community throughout the civil rights movement and urban renewal.

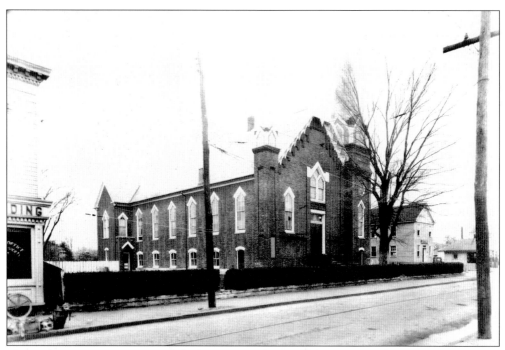
Shown here is First Baptist Church on King Street, founded in 1863. (Courtesy of First Baptist Church.)

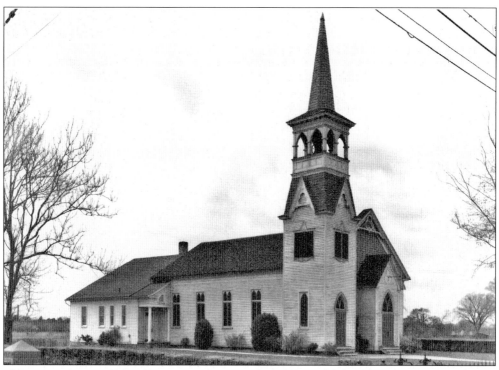
This is Zion Baptist Church on County Street, founded in 1863. (Courtesy of the Cheyne Collection/City of Hampton Museum.)

This is Bethel A.M.E. Church on Lincoln Street, founded in 1864. (Courtesy of Bethel A.M.E. Church.)

(below left) Rev. Lester Doc Lively pastored Ebenezer for 42 years, Morning Star, and Queen Street. He assisted in organizing Morning Star Baptist. He was known for developing strong church leaders. (Courtesy of Mrs. Ellen Lively Bolling.)
(below right) His successor, Rev. George Russell, pastored Queen Street for 31 years and Ebenezer for 26 years. He was widely known for his civic and community involvement. (Courtesy of Mr. and Mrs. Harold Jordan.)

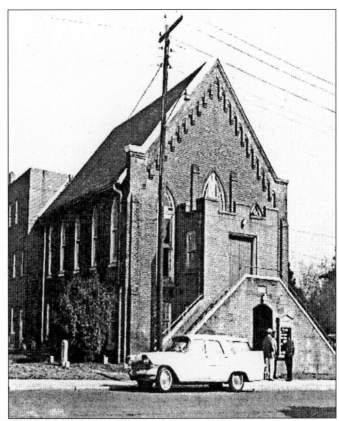

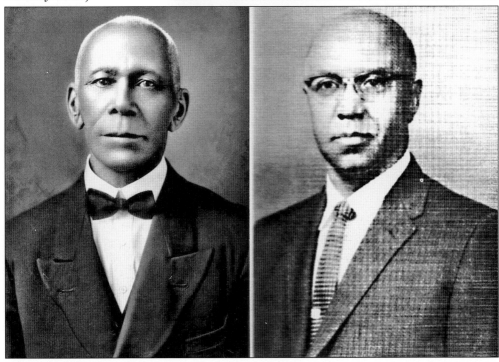

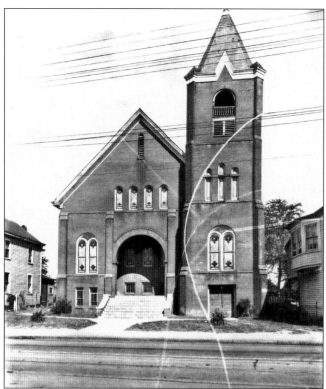

Queen Street Baptist Church, initially known as Second Baptist, was founded in 1865. (Courtesy of the Cheyne Collection/City of Hampton Museum.)

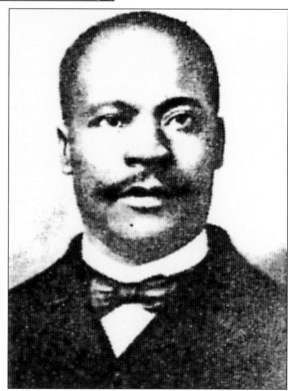

This is Rev. Thomas Shorts, third pastor of Queen Street. Under his pastorate, he started the Galilean Fishermen's Bank, the second black-owned bank in Hampton. (Courtesy of Mrs. Louise Walker Simpson.)

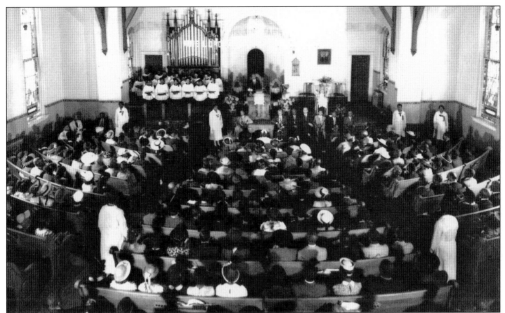

A common cultural artifact in the life of black churches is its decor. The decorated pulpit, uniformed ushers, and full choir lofts create an atmosphere for worship. An example of this fact is here in Queen Street, *c.* 1910. (Courtesy of the Cheyne Collection/City of Hampton Museum.)

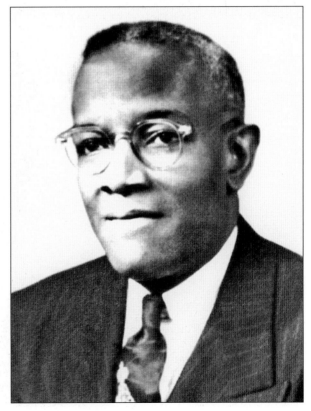

This is Rev. J. Dett Marshburn. He pastored several churches: Zion Baptist, Antioch, and Lebanon in Surry County. Reverend Marshburn is remembered for visiting his sick and shut-in and giving them a crisp new dollar bill from the bank. (Courtesy of Mrs. Frances Pickett Manns.)

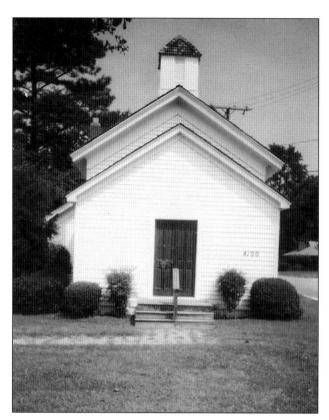

Little England Chapel was built between 1878 and 1880 to serve the Newtown community. It became a historic landmark in 1981. (Courtesy of Colita N. Fairfax.)

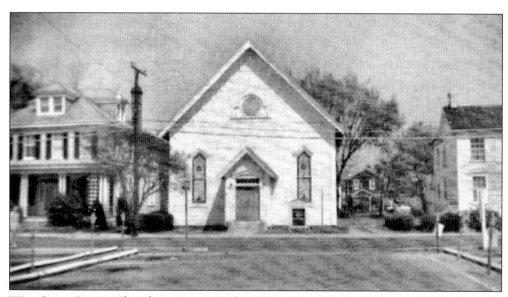

Wine Street Baptist Church was organized in 1881. Later it became known as Third Baptist Church. (Courtesy of Dr. Melvin Simpson.)

Rev. Henry Page Weeden was the first pastor of Third Baptist Church, and he also pastored Ebenezer Baptist. (Courtesy of Dr. Melvin Simpson.)

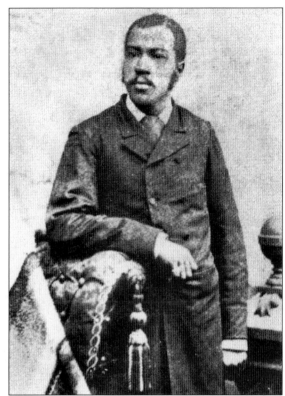

Ebenezer Baptist Church began to serve the Semple Farm community in 1884, providing a spiritual refuge for the community. (Courtesy of Mr. and Mrs. Harold Jordan.)

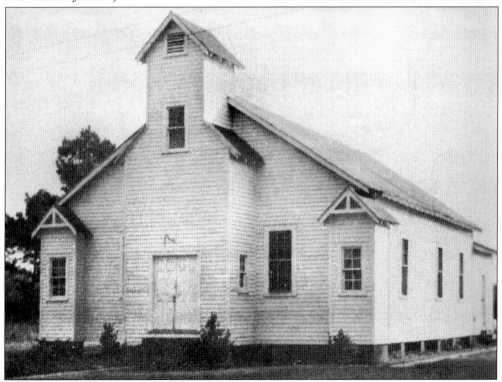

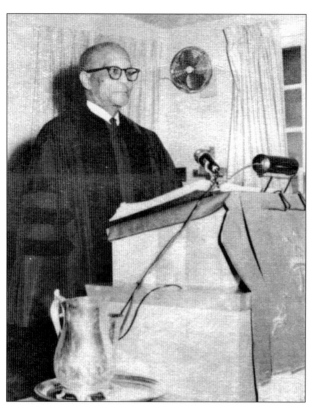

Rev. Isom Gilbert Gladden Sr. pastored Third Baptist for over 30 years. The church experienced growth under his leadership. (Courtesy of Dr. Melvin Simpson.)

The Buckroe community has been served by the Antioch Baptist Church since 1895. The first pastor was Rev. William N. Thornton, who was also the first pastor of Zion Baptist. (Courtesy of Deacon Odell Spradley.)

Morning Star Baptist was organized in 1896 to serve the Back River and Butler Farm communities. (Courtesy of Mr. Lewis Watts.)

St. Cyprian's was organized in 1905 as the only black Episcopal church in Hampton. (Courtesy of St. Cyprian's Church.)

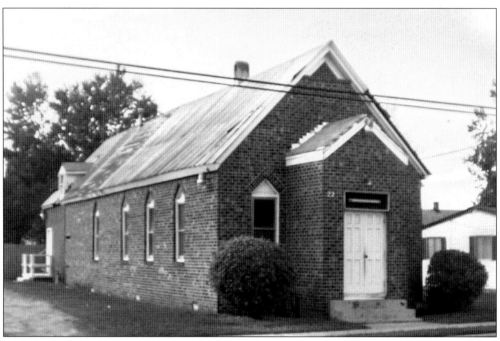

Bethel Christian Church was started in 1914, serving the Old Northhampton community. (Courtesy of Bethel Christian Church.)

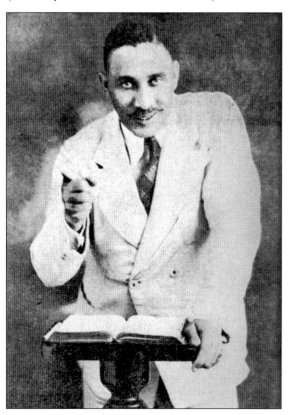

Elder Lightfoot Solomon Michaux established the Church of God of the Gospel Spreading Church, Inc., in Hampton in 1922. His company had a newspaper, farms, and other outlets. He had other churches in major cities, drawing thousands to hear him. Known as the "Happy am I" preacher, his radio broadcast opened with the "Happy am I" gospel song on WJSV. He was a political figure as well as a businessman. (Courtesy of Mrs. Juanita Haltiwanger.)

Pastors performed services that sustained family and community life. Here, Rev. J. Dett Marshburn performs a wedding. (Courtesy of Mrs. Frances Pickett Manns.)

This is Dr. James Walter Dodd, pastor of Little Zion Baptist Church for over 35 years. Little Zion was founded in 1885. (Courtesy of the Daily Press, Inc.)

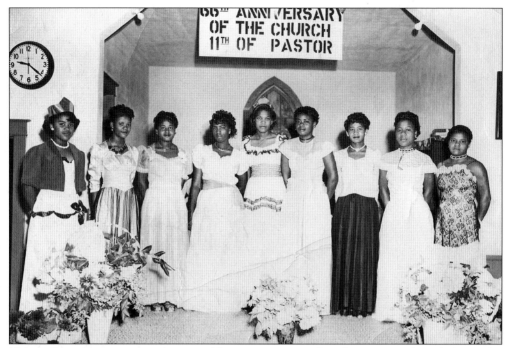

This is an anniversary committee at Ebenezer Baptist Church in 1950. These ladies, who composed the Junior Missionary Club, are from left to right Ms. Shirley Washington, Ms. Edith Coles, Ms. Thelma Randolph, Ms. Odell Randolph, Ms. Celestine Wynder (president), Ms. Gladys Brown (treasurer), Ms. Mildred Braxton, Ms. Mildred Borden, Ms. Elise Broadus (secretary), and Ms. Maggie Tabb (vice president). (Courtesy of Mrs. Celestine W. Carter.)

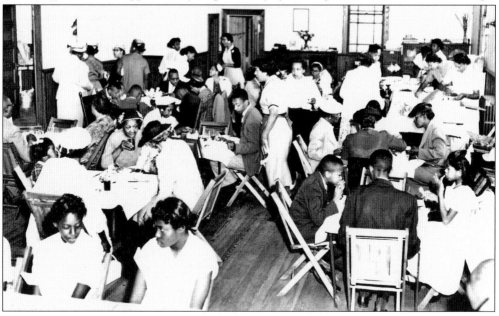

This is the fellowship hall of Zion Baptist Church. This photograph typifies a reception, homecoming, repass, or other occasion where parishioners gather to socialize. (Courtesy of Mrs. Frances Picket Manns.)

Six

THE THREE RS

Education has become the vehicle by which upward mobility is achieved for African Americans. Not only is education an intellectual activity, it has become an activity to upgrade one's quality of life through attainment of higher paying jobs, flexibility of occupations, and capabilities to buy homes in stable communities. Missionaries and blacks created one of the largest local Sabbath and weekday schools at the burned-out courthouse during the Civil War. Some students progressed so rapidly that it was necessary to divide them into primary and higher departments, making this school one of the first graded schools for freedmen in this area.[61] Courageous teachers like Mrs. Mary Peake violated Virginia laws and taught children under what is now known as Emancipation Oak and in the Butler (later known as Whittier) School. Butler School endured for 25 years on County Street. A school was started in the mansion of ex-President Tyler, which stood on East Queen Street. There was also a school at Old Point Comfort.

When the Butler School was built, at least 600 students attended. Another missionary school was established near Buckroe Beach. As in other communities throughout America, the 19th century was met with rigid segregationist laws regarding the education of blacks. However, blacks used schools to reinforce the prevailing values of the community.[62]

There were also one-room schools such as the Gatewood School, Banner School, Bates School, Little Red School, Semple Farm School, and Back River School with one teacher and several grades. Rev. Richard Spiller of First Baptist was principal of his own academy. Nannie Gaddis and Julia White ran small schools in downtown Hampton.[63] A. W .E. Bassette opened a school in a two-room building on Rip Rap Road in 1895. In 1905, the Tidewater Collegiate Institute opened with the Rev. W. Edward Read as principal, and the Rev. Ebenezer Hamilton of St. Cyprian's Episcopal Church held class in 1913 in a one-room schoolhouse.

In 1866, the graded school at the courthouse was relocated to Lincoln Street. The school was called the Lincoln School, becoming in 1870 part of the public school system that served the black community until the 20th century. The Union Street School replaced the Lincoln School.[64] Union Street developed into an academic school for black students. Principal Yarbourough Henry Thomas served for 25 years and expanded the curriculum at Union until requirements for it to be considered a high school were met. Six commencements were held for Union High School students before the last class graduated in June 1931.

The Virginia School for the Deaf and Blind was started due to a movement to educate black children with disabilities by William C. Ritter and his wife, Mary Alice Ritter, in 1906. Mr. Ritter was deaf. When the campus was established on 80 acres on Shell Road, it became the first state-supported dual school for deaf and blind black children.[65] It provided three types of training: pre-vocational, vocational, and industrial cooperative training. The curriculum for the deaf provided speech and auditory training. The first black superintendent was Mr. William J. McConnell, appointed in 1966.

In the fall of 1932, the George P. Phenix Training School opened on Hampton Institute's campus. The school was named after the first "president" of Hampton Institute. It housed both secondary and elementary students in a 25-classroom building. The purpose of Phenix was twofold: to provide an opportunity for practice teaching at both elementary and secondary levels for education majors, and to provide an elementary and secondary education for

black children. Phenix was recognized as a public school, although it was run and operated by Hampton Institute. The school moved to another facility on LaSalle Avenue in 1962, but closed in 1968. Pembroke High School opened in 1967 because the City of Hampton had not built a school for black children; however, Pembroke High closed in 1980.[66]

The desegregation of Hampton's school system was implemented due to the Civil Rights Act of 1964. Although there were no reported incidences of extremist ideology, there were personal threats hurled at the first black principal at Hampton High School. Mr. Wilbert Lovett remembers walking into his office and finding a Ku Klux Klan cap in his office chair.[67] Mr. Donald J. Montague was principal of Bethel High School during this period as well. The Hampton school system has honored several African Americans by naming schools after them. The Y. H. Thomas Middle School, the only black junior high, opened in 1953 but closed in 1968. In addition to Tarrant Elementary and the Mary Peake Center, Robert R. Moton Elementary School opened in 1948, the A. W. E. Bassette Elementary opened in 1971, and the William Mason Cooper Elementary School opened in 1975. Although there are no separate schools based upon race anymore, the years of segregated schooling did not deter the value of earning an education. The variety of one-room schools is a testimony to the indefatigable commitment blacks, who were one generation removed from enslavement, had to those generations born in the 20th century.

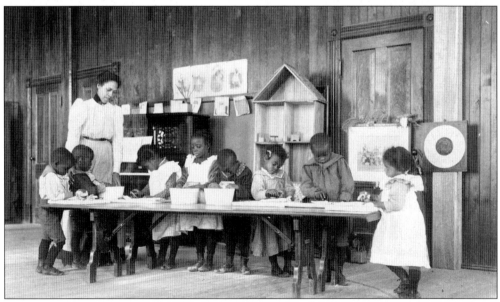

These are elementary students in the Whittier School at the turn of the 20th century. (Courtesy of the Cheyne Collection/City of Hampton Museum.)

This is Edward Bolling's Whittier report card from the 1926–1927 school year. (Courtesy of Mrs. Ellen Lively Bolling.)

This was the Little Red School, a one-room school in Elizabeth City County. It sits on the campus of Hampton University near Emancipation Oak. (Courtesy of Colita N. Fairfax.)

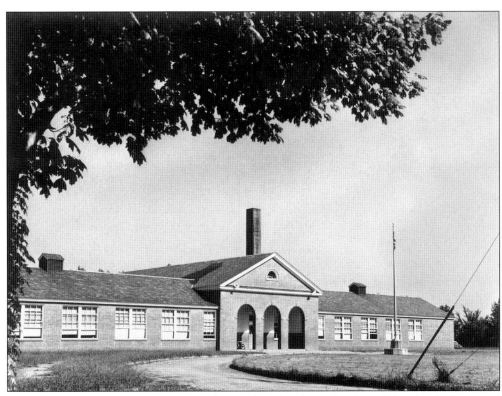

This is the Aberdeen Gardens School, which served its surrounding community. (Courtesy of the Daily Press, Inc.)

Mrs. Aurelia Dean Parker was a beloved teacher at Phenix High School. She attended the Whittier School. She was the wife of William Parker, pharmacist. (Courtesy of Ms. Aurelia Parker.)

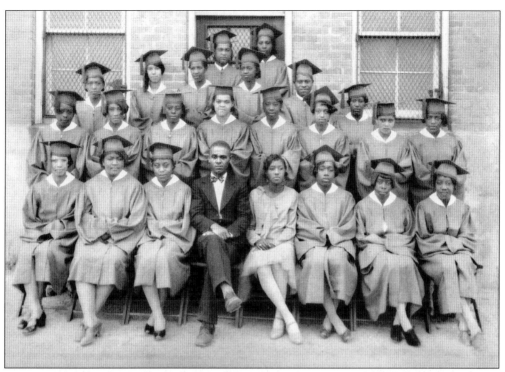

This is a Union Street School class of 1926 with Principal Yarbourough H. Thomas. (Courtesy of the Cheyne Collection/City of Hampton Museum.)

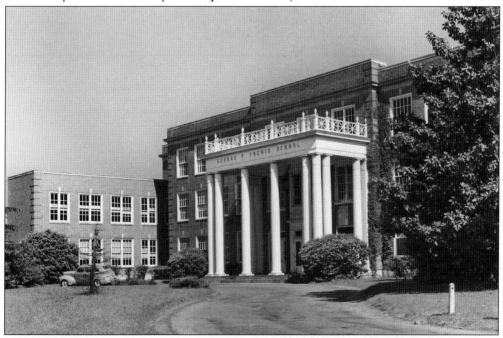

This is the George P. Phenix High School. It was located on Hampton's campus and was the only high school for black students between 1932 and 1968. (Courtesy of Mr. Rueben V. Burrell.)

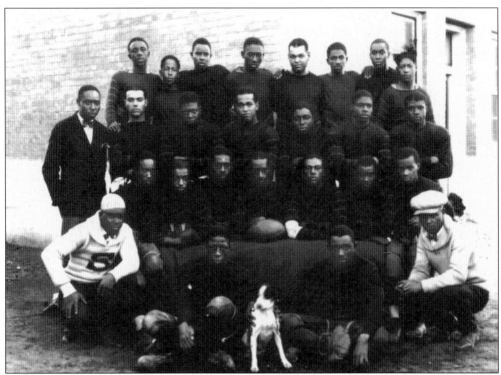
Black schools during segregation were highly organized units. This is the 1926 Union School football team, with the team dog. (Courtesy of the Cheyne Collection/City of Hampton Museum.)

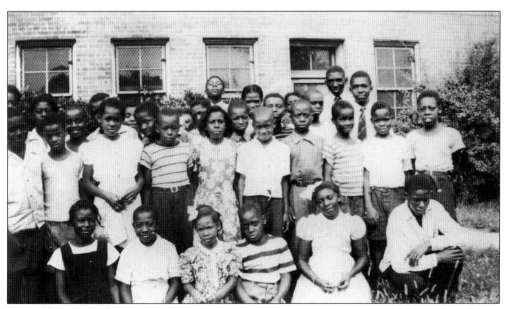
This photograph of schoolchildren shows Union Street students, *c.* 1940. (Courtesy of Mrs. Sadie Mannes Brown.)

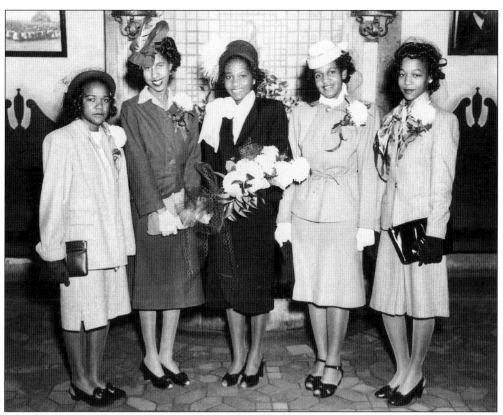
These beautiful ladies were on the 1948 homecoming court of Phenix High School. (Courtesy of Mrs. Louise Walker Simpson.)

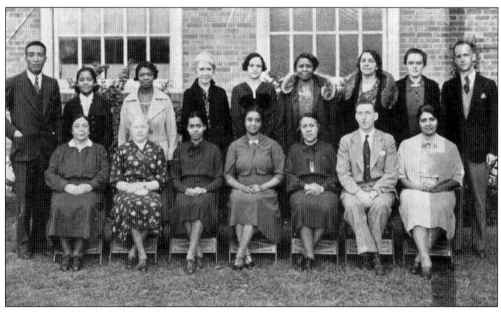
This is the 1938 Parent-Teacher Association. (Courtesy of Mrs. Julia R. Bassette.)

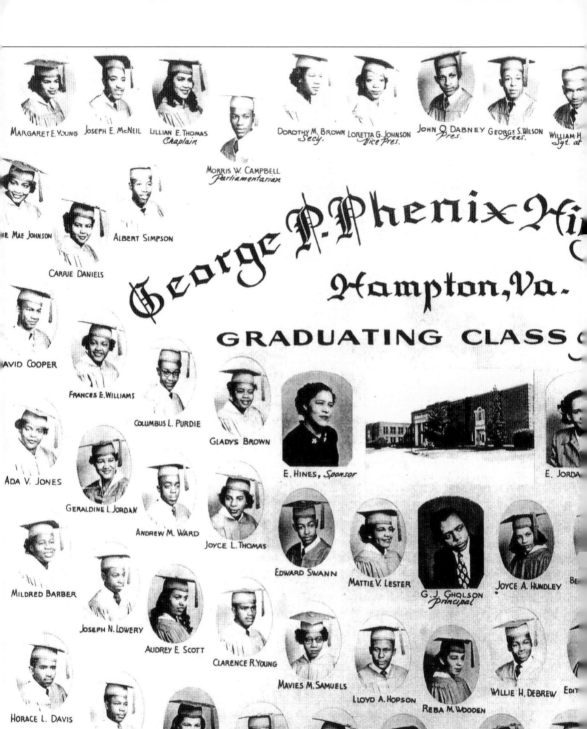

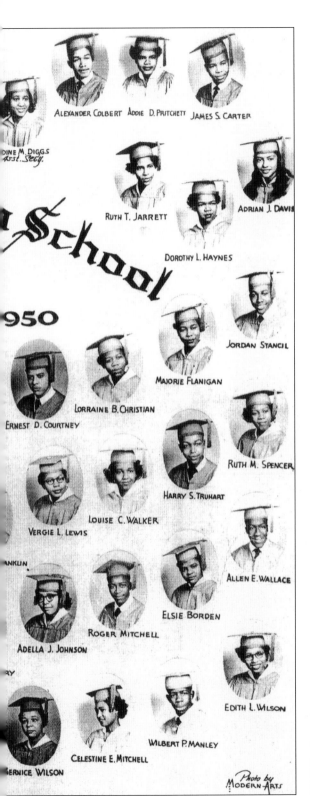

This class picture from 1950 shows the beauty of students attending Phenix High School. (Courtesy of Mr. Albert Simpson.)

Phenix High School was known for its students with athletic ability. Notice the precision. (Courtesy of Mr. Albert Simpson.)

The Virginia School participated in the Hampton Institute parade for many years. Here is the 1974 class banner. (Courtesy of the Daily Press, Inc.)

Mrs. Thelma Gary Boone taught at the Virginia School for 35 years. She was a teacher, supervisor of teachers, and principal of the blind/visually impaired. Mrs. Boone was a fierce advocate of the school, often writing the Virginia Assembly to keep continued funding. (Courtesy of Mrs. Thelma G. Boone.)

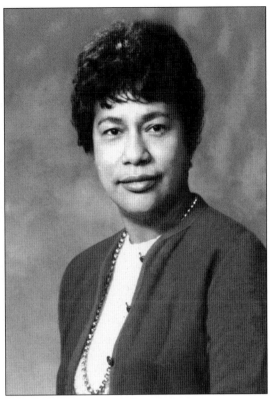

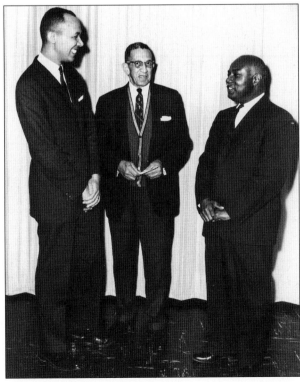

These are giants in the ongoing struggle for political parity: attorney William Alfred Smith; Dr. William Mason Cooper, Hampton's first black school board member; and Mr. Lawrence Barbour, business and civic leader. (Courtesy of Mrs. Catherine T. Barbour.)

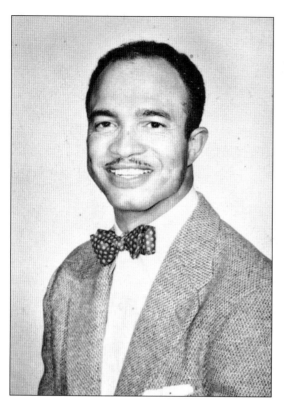

This is Mr. Wilbert L. Lovett, the first black senior-high principal of Hampton High School during the period of desegregation. (Courtesy of Mr. Wilbert Lovett.)

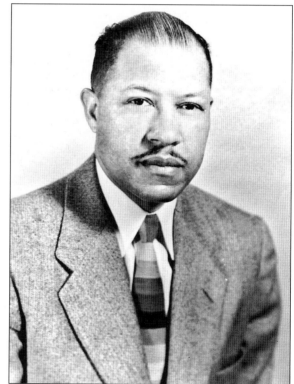

Attorney Hale Thompson of the NAACP provided legal expertise and support to the community during the desegregation era. (Courtesy of Mr. Rueben V. Burrell.)

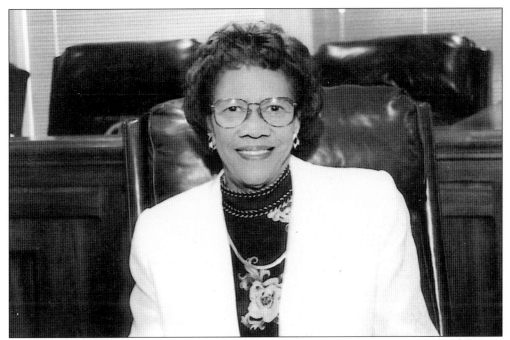

Dr. Mary T. Christian was a modern renaissance woman, starting her political trek with the Community Progress Committee (CPC). In addition to her role as the first African American woman school board member of Hampton, she served as the first African American woman Virginia state representative. (Courtesy of Dr. Mary T. Christian.)

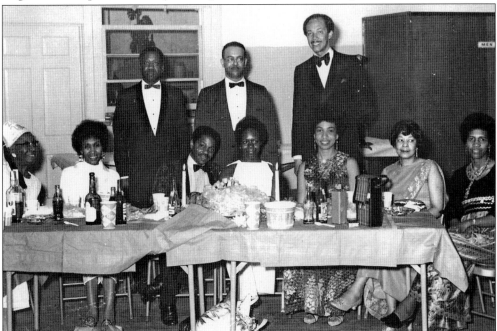

As desegregation entered history, the CPC was formed to create leadership that would be elected and pass legislation that would benefit the black community. This picture is of the CPC at an annual fund-raiser. (Courtesy of Mrs. Julia R. Bassette.)

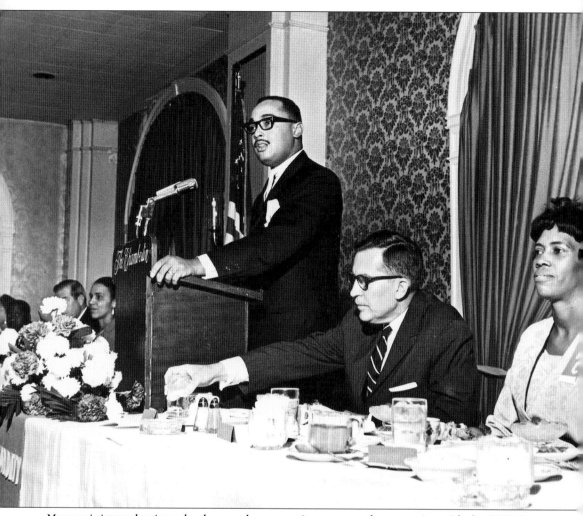

Many ministers, business leaders, and community personnel were active with the CPC. Rev. Calvin Jones was a founder of the CPC and pastor of Queen Street Baptist Church. Dr. Mary T. Christian is seated on the right end. (Courtesy of Mrs. Julia R. Bassette.)

Seven

STRIVING FOR POLITICAL POWER

Blacks truly believed that the political system was ready to accept their participation during Reconstruction. Several black state legislators represented Elizabeth City County: Alexander G. Lee, house of delegates, 1877–1878; Isaiah L. Lyons, senate, 1869–1971; Robert Norton, house of delegates, 1869–1890; James A. Fields, house of delegates, 1889–1990; and John H. Robinson, house of delegates, 1887–1888.[68] Their positions coincided with the gains in entrepreneurial ships, attainment of property, construction of schools and institutions, and home ownership.

In local offices, black businessmen and landowners took advantage of Reconstruction's political opportunities for leadership. Wealthy landowner and Queen Street merchant Thomas Harmon became a city councilman.[69] Robert M. Smith, who was in the Virginia House of Delegates from 1875 to 1877, became commissioner of revenue. Andrew Williams became county sheriff. Both these men were property owners. Thomas Peake briefly served as deputy sheriff and as overseer of the poor in 1870. Thomas Peake, widower of Mary Peake, contributed to the community through his work as a dispatcher during the Civil War, as community leader, and as a civil servant.

Thomas Canady was elected constable. Rufus Jones was elected clerk of the county court and served periodically as justice of the peace, as did attorney Luke Phillips. Rev. Young Jackson, pastor of First Baptist, and Sandy Parker, businessman and landowner, served on the county board of supervisors. Thomas Harmon, Luke Phillips, and William Roscoe Davis served on the city council in the late 1880s.[70] These occupations served the entire county. Possession of these offices did not amount to "black domination" of local government, but it did assure the community a powerful voice in local government.[71]

However, whites of the county were not yet reconciled to black possession of any office of real power. Black and white officials worked together; however, the surface appearance of harmony obscured the hostility toward black political participation. The Readjuster Movement, the most successful interracial political alliance in Reconstruction between 1879 and 1883, was disbanded, and the increase of the white demographic population would be the beginning of the end of black political participation.[72] White businessmen such as J. S. Darling, James McMenamin, and others resented the state and local political power attained by these men and conducted a full-scale assault on them, disarming a protective political shield formed around the community. Reconstruction ended without blacks maintaining their political positions, which would render the community vulnerable in the 20th century.

William Trusty was elected to the Phoebus town council in 1900, making him one of the first blacks to be elected in a Virginia municipality at the turn of the 20th century. He died in 1902 at age 40.[73] There was James Arthur Richardson Sr., the first black constable of Phoebus at the turn of the 20th century. Due to the dearth of black elected officials, organizations such as the Bachelor Benedicts and the Beau Brummell Club addressed civic, political, and economic collaborations in segregation, informally representing community interests from

the 1930s to the 1970s. Giants such as attorney William Alfred Smith, Lawrence Barbour, Andrew W. E. Bassette III, Clarence Williams, Rufus Brown, Don Davis Jr., and others were steadfast in politically organizing the community. The CPC was founded in 1966 to organize a political tank that would address new issues and create more political awareness. Members of the committee included Dr. Andrew W. E. Bassette III, Rev. Calvin Jones of Queen Street Baptist, Mrs. Rachel Bassette Noel, Dr. David McAllister, Mr. Dardy, Mrs. Julia R. Bassette, Mr. John Brown, and Dr. Roscoe Wisner.

It was not until 1974 when John Mallory Phillips, a grandson of the black seafood giant and his namesake, would win a seat on city council and ultimately become the first black vice mayor, serving between 1982 and 1986. In 1984, Ms. Brenda Wharton became the first black woman to serve on city council. She served two four-year terms. Dr. Turner Spencer was appointed by Mayor James Eason to replace John Phillips as councilman in 1986, a post he continues to hold. Mr. Phillips could no longer complete his term. Dr. Spencer is also a professor emeritus at Thomas Nelson Community College. In 1996, Paige Washington would begin his two four-year terms from 1996 to 2004. In 1992, B. J. Roberts would become the first African American elected sheriff post-Reconstruction. George Wallace Jr. became the first African American to serve as the city manager between 1997 and 2005. Mrs. Linda Batchelor Smith would become the first African American female clerk of circuit court in 2004.

Dr. William Mason Cooper was the first black school board member in the history of Hampton, serving from 1962 to 1970. He would also serve as vice chair of the board. Dr. George Cypress, Alphonso M. King, Joseph M. King (no relation), and Dr. Mary Taylor Christian followed Dr. Cooper to be early African American school board members. Dr. Mary Taylor Christian, Hampton University professor, became the first African American female on the school board in 1975, serving for six years. A true trailblazer in civic and political circles, in 1986 she would also become Hampton's first African American to become a state representative post-Reconstruction. As state representative, Dr. Christian was the first African American to serve on the appropriations committee and first female chair of the Virginia State Legislative Black Caucus.

Dr. Mamie Locke, dean of liberal arts and education and professor of political science at Hampton University, would become the second African American female on city council, serving from 1996 to 2004, following Rev. Henry Maxwell of Newport News. She was also vice mayor from 1998 to 2000. Locke would become the first African American mayor of Hampton in 2000 and later the first African American female state senator in 2004. Attorney Robert "Bobby" Scott would be the first African American congressional representative since Reconstruction. A native of Newport News, Scott served in the Virginia House of Delegates from 1979 to 1983 and in the Virginia State Senate from 1983 to 1992. He has served as a Congressional representative since 1992. Completing this political historiography are two new state representatives elected in 2004, Mrs. Jeion Ward and Mrs. Mamye BaCote.

(near right) This is John Mallory Phillips, businessman. He became a city councilman in 1974 and the first black vice mayor in 1982. (Courtesy of Mrs. Josephine Harmon Williams.)
(far right) Mrs. Brenda Wharton ran for a city council position and won in 1984. (Courtesy of Mrs. Brenda Wharton Taylor.)

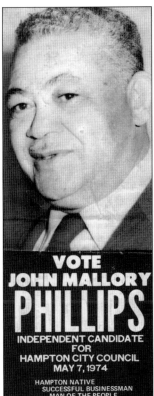
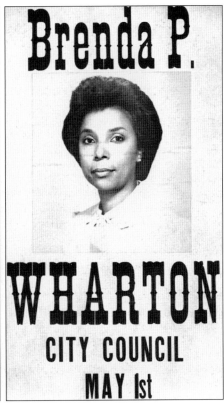

(above left) Dr. Turner Spencer has been the longest running African American city councilman. His term started in 1986. (Courtesy of Dr. Turner Spencer.)
(above right) Mr. Paige Washington served on city council from 1996 to 2004. (Courtesy of Mr. Paige Washington.)

This is Dr. Mamie Locke. She was the first African American mayor of Hampton and the first African American woman state senator in 2004. (Courtesy of Dr. Mamie Locke.)

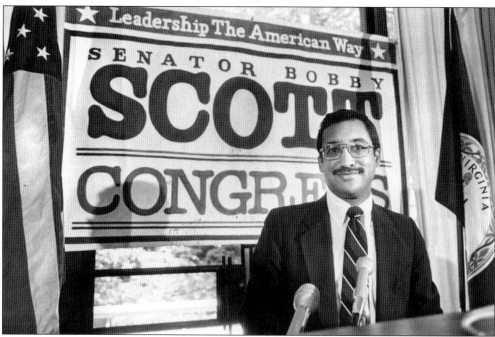

Congressional representative Bobby Scott has served his district since 1982. He is the first African American in post-Reconstruction to represent parts of Virginia. An attorney, Scott has a solid reputation. (Courtesy of the Daily Press, Inc.)

Eight

BAY SHORE

Black citizens of Hampton desired to have a resort on the water that would cater to the community. During Reconstruction, the Bay Shore Hotel Company was formed, and a waterfront property was purchased in the fall of 1897. The first directors were J. H. Evans, J. L. Fountain, Thomas Harmon, D. R. Lewis, F. D. Banks, Robert R. Moton, Alexander Gardiner Jr., John M. Phillips, and Richard R. Palmer. The hotel opened in the summer of 1898.[74] It was a wonderful resort that provided the community an opportunity to enjoy the ocean and escape the nefarious system of segregation. For years, Bay Shore was the mecca of the black vacationist.[75] The August 23, 1933, storm decimated the resort; however, it was later rebuilt.

Segregationist policy of 1912, Chapter 157, prohibited the social interaction of racial groups in public places, so the black community sought its own places of leisure. In the 1940s, Joseph E. Healy, president of People's Building and Loan Association; Lawrence Barbour; and Charles H. Williams worked to recover Bay Shore. The New Bay Shore Corporation expanded and developed the site once again. The New Bay Shore Amusement Park operated well into the 1960s. The beach attracted thousands of vacationing blacks from Richmond, Roanoke, Washington, D.C., Baltimore, New York, and cities in North Carolina. Persons would spend honeymoons at Bay Shore. There would be picnics, dances, and various celebrations at the resort.[76]

Cab Calloway, Duke Ellington, Ella Fitzgerald, Louis Armstrong, and other entertainers would perform at the resort. Red Foxx, the "dean of black humor," visited as well. However, in the late 1960s, the hotel and amusement park lost money. In 1973, the directors were forced to discontinue the operation, and the property was sold to private developers. Bay Shore's existence is evidence that the community could create a space of gratification and delight, but also evidence that perhaps the community's preoccupation with the civil rights and black power movements compromised its survival.

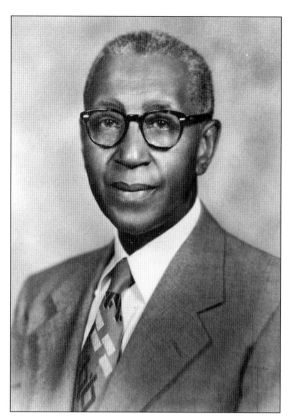

This is Charles H. Williams, principal developer in the New Bay Shore Cooperation. As a civic leader, athletic director at Hampton Institute, and businessman, he successfully recovered Bay Shore, and another generation enjoyed the beach in the middle of the 20th century. (Courtesy of Mr. Rueben V. Burrell.)

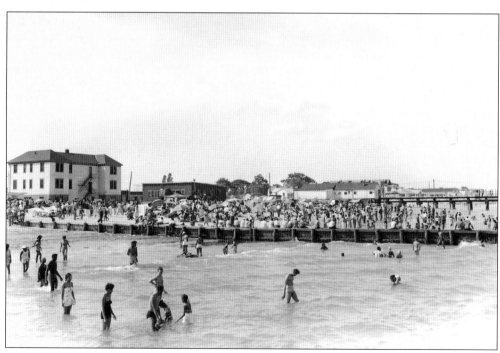

These are vacationers at Bay Shore Beach, *c.* 1950. (Courtesy of Mr. Rueben V. Burrell.)

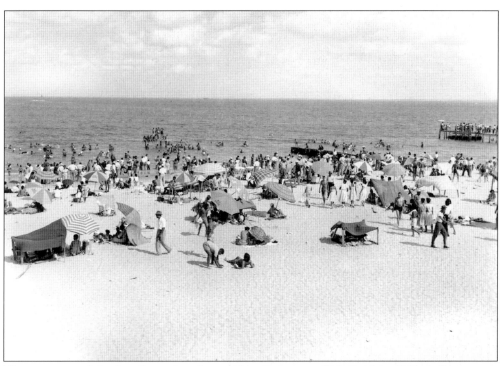

This is a view of the Bay Shore Beach, *c.* 1950. (Courtesy of Mr. Rueben V. Burrell.)

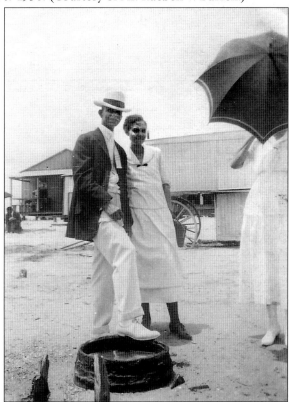

Here are William and Mae Beamon Reid enjoying Bay Shore, *c.* 1910. (Courtesy of Ms. Cora Mae Reid.)

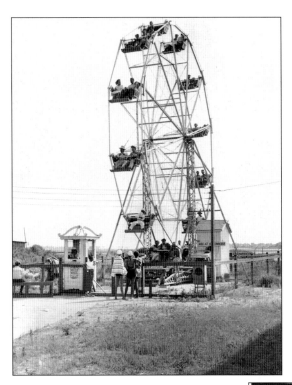

This is the Ferris wheel that was apart of the amusement park at Bay Shore. (Courtesy of Mr. Rueben V. Burrell.)

These tickets were used for admission to the Bay Shore Beach Amusement Park. (Courtesy of the City of Hampton Museum.)

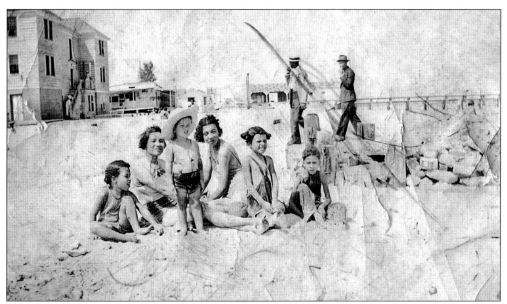

Scenes like these were common as families such as the Williams family enjoyed one another at Bay Shore. (Courtesy of Mrs. Lillian Williams Lovett.)

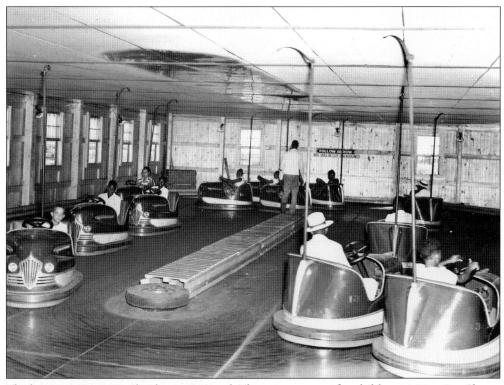

The bumper cars proved to be sensational. They were a must for children visiting Bay Shore. (Courtesy of Mr. Rueben V. Burrell.)

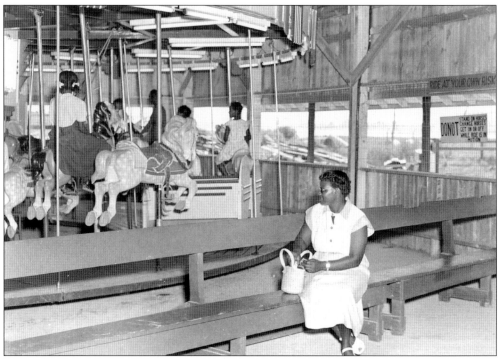
The merry-go-round was another attraction that Bay Shore offered. (Courtesy of Mr. Rueben V. Burrell.)

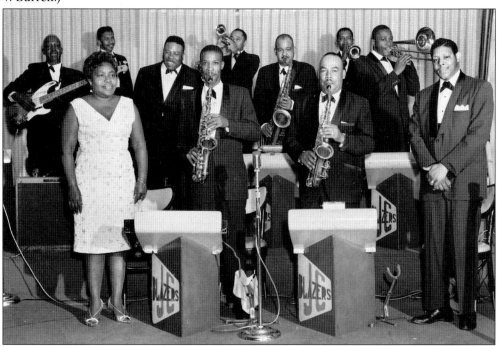
This local band, The Blazers, was among acts that were featured at Bay Shore and throughout black Hampton. Jap Curry founded The Blazers in 1948. Third from the left on the front row, he played the alto sax. (Courtesy of Mr. and Mrs. Clarence "Jap" Curry.)

Nine

LANGLEY FIELD AND NASA

In August 1916, the U.S. government decided to purchase 1,659.4 acres for building a U.S. Army aviation field and an aeronautical experimental station. The joint venture between the U.S. Army Signal Corps and the National Advisory Committee for Aeronautics (NACA) was to supervise and direct the scientific study of flight.[77] It became the nation's first aeronautics laboratory. The field is named after Samuel Pierpont Langley, secretary of the Smithsonian Institution and aviation pioneer.

Hampton Institute sold acres to the government, which it had used for its trade school program. The trade school students performed special machine work for the airplanes at Langley.[78] Phenix High School students also used the field for extracurricular activities.

Between 1941 and 1944, 30 black units of various types resided at Langley. In 1941, the 1st Aviation Squadron, one of the first units in the U.S. Army Air Force, was activated at the field. The squadron relieved tactical units undergoing training and had other responsibilities, including area policy, guard duty, runway repair, truck driving, and fireman details.[79] Other African American units were five quartermaster truck companies, three engineer battalions (aviation), and the 466th Army Air Forces Band. The Eastern Signal Aviation Unit Training Center (ESAUTC) in 1943 to train a large number of black troops to construct and maintain semi-permanent communications lines between airfields. State segregationist laws promoted the separation of barbershops, service clubs, and post-exchange. However, during this period, Colonel Lohman opened the library, gymnasium, and theaters to all troops.[80]

Many Air Force servicemen based at Langley dated and married ladies at Hampton Institute and the Dixie Hospital. These couples purchased homes in Garden City, Dunbar Gardens, and other communities that provided a desirable environment to raise children. Other servicemen retired at Langley but continued to reside in Hampton, such as Capt. Moses Meadows and Maj. Nathaniel Fairfax. Tuskegee Airmen also retired in Hampton. Lt. Col. Francis Horne, Mstr. Sgt. Ezra Hill, Mstr. Sgt. Grant Williams Sr., and Lt. James L. Williams are just a few names of those men who served gallantly during World War II. In 1998, the first African American command chief master sergeant, Bruce Robinson, was appointed at Langley.

With the growth of the space industry, Langley/NACA began to hire mathematicians who solved complex algebraic equations and calculations and performed wind tunnel research. Although Pres. Harry Truman's Executive Order 9981 in 1948 integrated the military, black women worked at a segregated NACA around the 1950s. Katherine Goble Johnson, Mary Winston Jackson, Daisy Alston, Eunice G. Smith, Erma Tynes Walker, Barbara B. Holley, Willie Terrell Ruffin, Arminta S. Cooke, Christine Richie, Kathaleen Land, and Dorothy Vaughan who was their supervisor had the opportunity to work in a discipline they were college-trained in as a result of Executive Order 9981. In 1958, NASA replaced NACA, starting the beginning of the study of science and technology in space science.

These women's contributions were momentous to the success of NASA. For example, the calculations of Katherine G. Johnson placed Alan Shepard, America's first astronaut, into space in 1961. She also charted courses for astronauts John Glenn in 1962 and Neil Armstrong in 1969.[81] Daisy Williams Alston's 1981 master's thesis at Hampton Institute has been read globally, and she is regarded a pioneer in statistical modeling. The presence of these brilliant mathematicians helped to make the NASA program a dominating force in the global world.

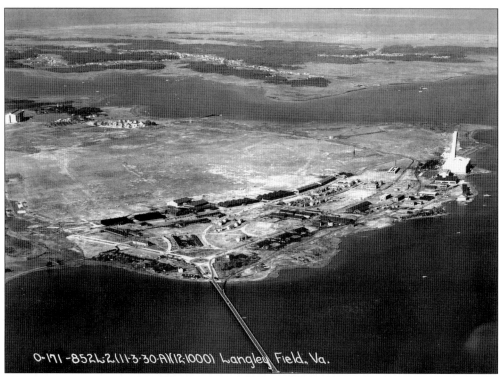

This is an aerial view of Langley. (Courtesy of the Daily Press, Inc.)

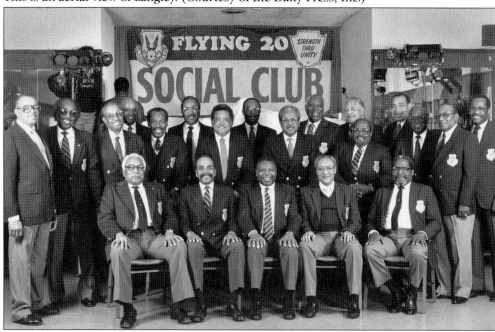

These men made up the Flying 20, a social organization founded in 1974 for African American Air Force men who served 20 years and over in the military. They developed their own insignia and have provided community service for over 30 years. (Courtesy of Mr. William Veals.)

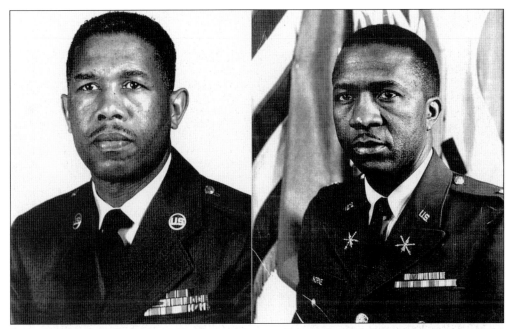

Here Hampton hosts retired Tuskegee Airmen. Mstr. Sgt. Grant Williams Sr. is on the left. On the right is Lt. Col. Francis Horne. (Courtesy of Mr. Grant Williams Sr. and Lt. Col Horne, respectively.)

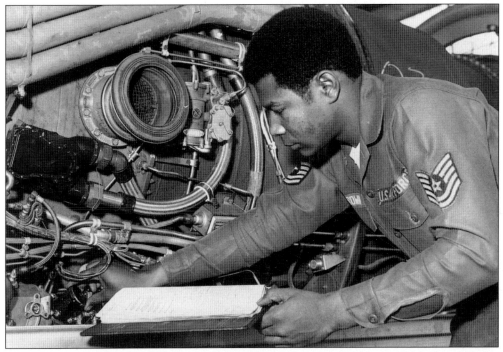

Some black men were supply personnel, who fixed planes and other machinery on Langley Air Force Base. (Courtesy of Daily Press, Inc.)

Here is Mrs. Katherine G. Johnson, noted mathematician who charted the course for American astronauts. (Courtesy of Mrs. Katherine G. Johnson.)

Shown here is Mrs. Daisy Alston, who conducted wind tunnel research. (Courtesy of Mrs. Daisy W. Alston.)

Mary Winston Jackson was among the first group of black women to be employed at NASA in the 1950s. (Courtesy of Langley/NASA.)

This is Langley's first African American command chief master sergeant, Bruce Robinson. (Courtesy of Langley Air Force Base.)

This is Staff Sgt. Robert Keyes and his wife, nurse Shirley Moore. Like many other couples, they met and married in 1956 as a result of "the triangle"—the Air Force base, Hampton Institute, and Dixie Hospital. He was stationed at Langley, and she was at Dixie. (Courtesy of Mrs. Shirley M. Keyes.)

Many Air Force men retired at Langley after serving. An example is Maj. Nathaniel Fairfax, who retired in 1974. (Courtesy of Mrs. Helen T. Fairfax.)

NOTES

[1] Robert Engs. *Freedom's First Generation: Black Hampton, Virginia 1861–1890*. (Philadelphia: University of Pennsylvania Press, 1979), 18.
[2] James T. Stensvaag, ed. *Hampton, From the Sea to the Stars: 1610–1985*. (Norfolk, VA: The Donning Company, 1985), 31.
[3] Engs. *Freedom's First Generation*, 18.
[4] Stensvaag. *Hampton, From the Sea to the Stars*, 31.
[5] The Casemate Papers: Highlights of Black History at Fort Monroe. The Casemate Museum, Hampton, VA, 1979.
[6] Ella Forbes. *African American Women During the Civil War*. (New York: Garland Press, 1998), 138.
[7] P. K. Rose. "The Civil War: Black American Contributions to Union Intelligence," *Studies in Intelligence*, 1998, 2.
[8] Stensvaag. *Hampton, From the Sea to the Stars*, 34
[9] John V. Quarstein. *The Civil War on the Virginia Peninsula*. Portsmouth, NH: Arcadia Publishing, 1997), 52.
[10] Ibid., 58.
[11] Engs. *Freedom's First Generation*, 34.
[12] The Casemate Papers.
[13] Forbes. *African American Women*, 175.
[14] Engs. *Freedom's First Generation*, 30–35.
[15] Ibid., 45.
[16] Chester D. Bradley. "Controversial Ben Butler." (Casemate Museum Papers, Hampton, VA, 1979), 6.
[17] Engs. *Freedom's First Generation*, 142.
[18] Stensvaag. *Hampton, From the Sea to the Stars*, 101–102.
[19] Engs. *Freedom's First Generation*, 144.
[2] Ibid., 147.
[21] Keith L. Schall. *Stony the Road: Chapters in the History of Hampton Institute*. (Charlottesville, VA: University of Virginia Press, 1977), ix–x.
[22] Mae Boone Pleasant. *Hampton University: Our Home by the Sea*. (Norfolk, VA: The Donning Company, 1992), 48.
[23] Ibid., 49.
[24] Ibid., 63.
[25] Engs. *Freedom's First Generation*, 158.
[26] Stensvaag. *Hampton, From the Sea to the Stars*, 104.
[27] Ibid., 106.
[28] Pleasant. *Hampton University*, 67.
[29] www.hamptonroadshistorytours.com
[30] Ibid., 85.
[31] Ibid., 92.
[32] Ibid., 110–111.
[33] Ibid., 120.
[34] Stensvaag. *Hampton, From the Sea to the Stars*, 102–103.
[35] Engs. *Freedom's First Generation*, 166–171.
[36] Ibid., 173.
[37] Ibid., 173–174.

[38] Wilma Peebles-Wilkins. "Janie Porter Barrett and the Virginia Industrial School for Colored Girls: Community Response to the Needs of African American Children," in Iris Carlton-LaNey, ed. *African American Leadership: An Empowerment Tradition in Social Welfare History*. (Washington, D.C.: NASW Press, 2001), 127.

[39] Roberta Nicholls. "Weaver Home: Proof There's A Land of Hearts Desire." *The Daily Press*. (Newport News, VA: publisher?, 1965), page number?

[40] Engs. *Freedom's First Generation*, 185.

[41] Interview with Ermany Taylor by Colita N. Fairfax on January 25, 2005.

[42] Interview with Harold Jordan by Colita N. Fairfax on February 17, 2005.

[43] Interview with Mrs. Ellen Lively Bolling by Colita N. Fairfax on March 9, 2005.

[44] Bradley. "Controversial Ben Butler," 6.

[45] Interview with Mrs. Mary Thomas Johnson by Colita N. Fairfax on September 13, 2004.

[46] Osceola S. Ailor and Carolyn H. Hawkins. *Little England Chapel: A Black Landmark in Hampton, Virginia*. (Hampton, VA: Gear Printing: 1993), 4.

[47] Interview with Mr. and Mrs. Clarence Curry by Colita N. Fairfax on February 21, 2005.

[48] Patrick Tracey. "Coming Full Circle." *Historic Preservation: The Magazine of the National Trust for Historic Preservation*. (1995), 113–114.

[49] Interview with Rev. and Mrs. William Webster by Colita N. Fairfax on April 1, 2005.

[50] Engs. *Freedom's First Generation*, 181.

[51] Ibid., 184.

[52] The History First Baptist Church, Hampton, VA, 1995, 3–4.

[53] Bethel A.M.E. Church, Hampton, VA: The Historical Perspective, 2002, 1.

[54] A History of Queen Street Baptist Church, Hampton, Virginia, 1990, 1–2.

[55] Ailor and Hawkins. *Little England Chapel*, 3.

[56] Third Baptist Church 100th Anniversary Program, Hampton, VA, 1981, 2.

[57] Historical Sketch of Ebenezer Baptist Church, 100th Anniversary Program, Hampton, VA, 1984, 7.

[58] Antioch Church History, Hampton, Virginia, 2000, 1.

[59] A Brief History of St. Cyprian's Episcopal Church, Hampton, VA, 1998, 2–4.

[60] A Brief History of Bethel Christian Church, 2004, 1.

[61] Engs. *Freedom's First Generation*, 186.

[62] Ibid., 186.

[63] Ibid., 186.

[64] Stensvaag. *Hampton, From the Sea to the Stars*, 101.

[65] Ibid., 107.

[66] Ibid., 113.

[67] Interview with Wilbert Lovett by Colita N. Fairfax on February

[68] Luther P. Jackson. *Negro Officeholders in Virginia*. (Norfolk, VA: Guide Quality Press, 1945), 24–40.

[69] Ibid., 62.

[70] Ibid., 24.

[71] Engs. *Freedom's First Generation*, 191.

[72] Ibid., 192.

[73] Calder Loth, ed. *Virginia Landmarks of Black History*. (Charlottesville, VA: University of Virginia Press, 1995), 172.

[74] Stensvaag. *Hampton, From the Sea to the Stars*, 173.

[75] *The Negro in Virginia*. (Sponsored by Hampton Institute, NY: Hastings House, 1940), 302.

[76] Interview with Rueben Burrell by Colita N. Fairfax on March 3, 2005.

[77] *Langley 1916–1996*. (Office of History Air Combat Command, Langley Air Force Base, Hampton, VA, 1996), 1.

[78] Pleasant. *Hampton University*, 89.

[79] Langley., 94.

[80] Ibid., 94.

[81] Interview with Katherine Goble Johnson by Colita N. Fairfax on March 21, 2005.